THE **SECRET LIVES** OF **BACKYARD BUGS**

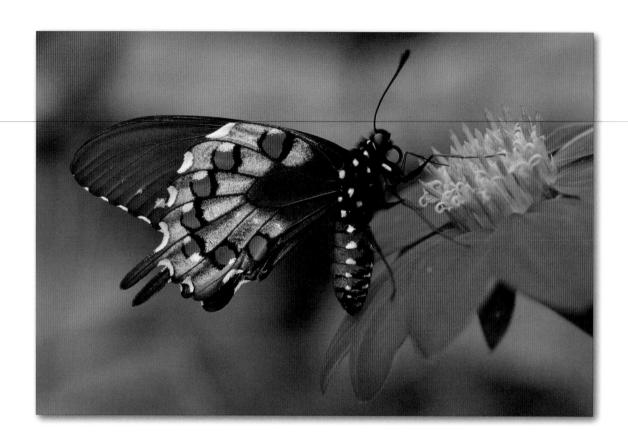

THE
SECRET LIVES OF
BACKYARD
BUGS

DISCOVER AMAZING BUTTERFLIES, MOTHS, SPIDERS, DRAGONFLIES, AND OTHER INSECTS!

JUDY BURRIS and **WAYNE RICHARDS**

Storey Publishing

The mission of Storey Publishing is to serve our customers by publishing practical information that encourages personal independence in harmony with the environment.

Edited by Claire Golding, Sarah Guare, and Gwen Steege
Art direction by Mary Winkelman Velgos
Book design and text production by Tracy Sunrize Johnson

Cover and interior photography by © Judy Burris and Wayne & Christina Richards, except for Charles T. and John R. Bryson, Bugwood.org : 60 top; © Cathy Keifer/Dreamstime.com: 80 bottom inset; © Edith Smith: 82 top and 83 bottom; © Hazel Proudlove/ iStockphoto.com: 119 top; © John Yuschock/Dreamstime.com: 19 bottom, 116 second row left; © Michael Quinton/Minden Pictures: 3 top left; © Robert Schantz/ Alamy: 72 top; © Scott Camazine/Alamy: 102 2nd row right; © Stephen Bonk/iStockphoto.com: 121 top
Prepress by Hartley Batchelder
Illustrations by © David Wysotski/Allure

Indexed by Christine R. Lindemer, Boston Road Communications
Expert review by Chris Eaton, Mass Audobon
Review of plants by Barbara Ellis

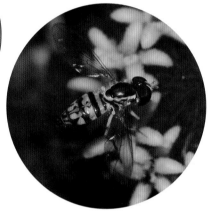

© 2011 by Judy Burris and Wayne Richards

Storey Publishing
210 MASS MoCA Way
North Adams, MA 01247
www.storey.com

Printed in the United States by Versa Press
10 9 8 7 6 5 4 3 2

LIBRARY OF CONGRESS CATALOGING-IN-PUBLICATION DATA

Burris, Judy, 1967–
 The secret lives of backyard bugs / by Judy Burris and Wayne Richards.
 p. cm.
 Includes index.
 ISBN 978-1-60342-563-6 (pbk. : alk. paper)
 ISBN 978-1-60342-985-6 (hardcover : alk. paper)
 1. Insects—Behavior—Pictorial works. 2. Backyard gardens—Pictorial works.
 I. Richards, Wayne, 1970- II. Title.
QL496.B88 2011
595.7175′54—dc22
 2010051177

We dedicate this book
to gardeners, backyard explorers,
and nature lovers everywhere.

CONTENTS

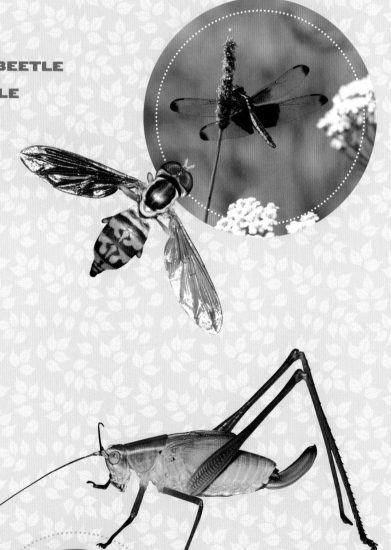

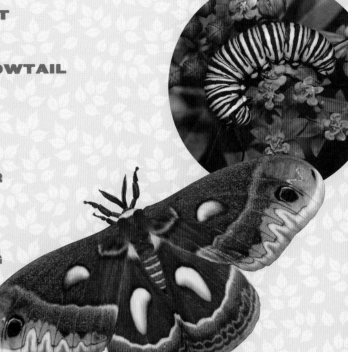

PREFACE

This book is an accumulation of many years of exploration and research. In our first book, *The Life Cycles of Butterflies* (Storey, 2006), we showcased the miraculous metamorphosis of plump and homely caterpillars into graceful winged beauties. A welcome and unexpected result of studying butterflies was the discovery of the interesting lives of other creatures near us.

We are a sister-and-brother author/photographer team, and Wayne's wife, Christina, also a nature photographer, regularly shares her work with us. We're the kind of people who like to get our hands dirty: we flip over moss-covered rocks to find squirmy things to photograph; we climb trees to retrieve interesting caterpillars to raise at home; we lie in the damp grass, risking the blood-thirsty attacks of chiggers, to get a bug's-eye view of a particularly lovely spring flower. In essence, we're kids who never grew up.

We hope this book will inspire nature lovers of all ages and levels of expertise. About 90 percent of the photos were taken in a backyard garden in northern Kentucky only one-eighth of an acre in size. Digital cameras with macro lenses enable us to bring the smallest, most magical details to life. So, after you've read about our assorted adventures as gardeners, photographers, and crazy critter caretakers, it's your turn. With the exception of the lightning bug, all of the bugs in this book can be found throughout the United States and parts of Canada and Mexico. Explore your backyard, gardens, and local parks and see what you can find. Take your camera, journal, family, and friends with you, and find out what's just waiting to be discovered.

Judy Burris, Wayne Richards & Christina Richards

Throughout this book, we have recommended a wide variety of plants that attract, feed, and shelter the featured bugs. Most are native species. Nonnative species that may be invasive are marked with an asterisk (*). Invasives vary from region to region. Please consult your local extension service, botanical garden, nursery, or conservation organization for a list of plants that may be invasive in your area. Also ask for a list of native plants that are suitable for your area.

INTRODUCTION

Every living thing progresses through a series of developmental stages, or life cycles, as it grows and matures. Plants begin as seeds, mushrooms as spores, insects and animals as eggs. It's easy to overlook these tiny first stages of life unless you know what time of year to look, where and how to search, and what to look for.

Once you start paying attention to the many lives being lived all around you, you probably won't want to stop! Every year we feel a sense of wonder as healthy vegetables grow from the tiny seeds we sprinkle. We're fascinated by the fragile seedlings we nurture as they become tall sunflowers, providing food for songbirds, squirrels, and chipmunks. Again and again we're filled with awe and astonishment when we witness a metamorphosis from egg to caterpillar to chrysalis and then watch a butterfly emerge and take flight.

You can begin *your* discovery of life cycles by just looking outside.

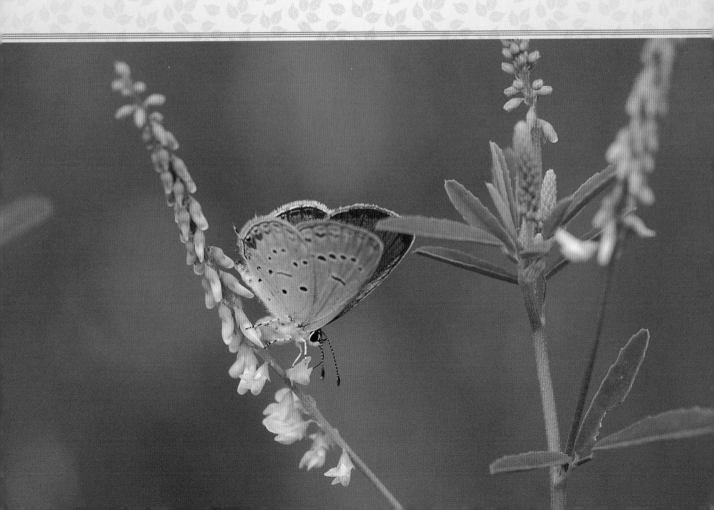

SEASONAL CYCLES

You may not have thought of it this way before, but every garden — whether it's a tiny city park, a roof garden, a big backyard, or a thousand-acre farm — goes through life-cycle stages. Each season affects it in a different way, creating a separate and unique identity and purpose.

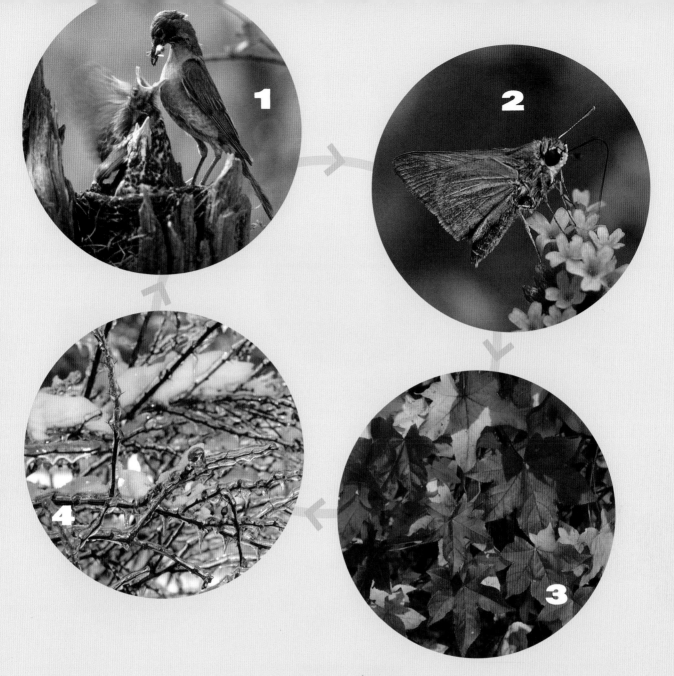

1 *In spring,* plants, insects, and animals that have been dormant through the winter awaken as the days get longer and warmer.

2 *The summer garden* comes alive with creatures hunting for food and raising their young. Plants and trees produce leaves and flowers that help feed hungry caterpillars, rabbits, and deer.

3 *In the fall,* as daylight hours begin to wane, chlorophyll gradually disappears from plant and tree leaves, revealing vibrant reds, oranges, and golds. Some insects migrate; others prepare for their own kind of hibernation.

4 *In winter,* most plants drop their leaves, and trees and perennial plants send nutrient-rich sap down to their roots for storage. Insects store sugar in their bodies that acts like antifreeze in their blood, preventing their cells from bursting and keeping them alive during cold weather. Insects that over-winter in their adult form, such as ladybugs, find a sheltered area and hide there until spring.

PLANT LIFE CYCLES

The broad seasonal changes that go on in every garden are easy to see. But each plant also has its own developmental stages that you can discover when you look more closely.

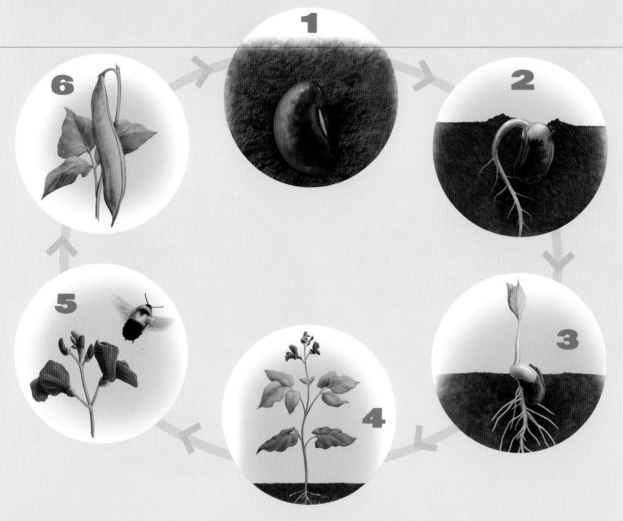

1 *Seed.* Every flowering plant begins as a seed. Each seed contains an embryo.

2 *Germination.* Water causes the seed to swell and germinate, bursting out of its hard coating. Oxygen gives the seed energy until its leaves develop.

3 *Growth of shoots and roots.* The stem and seed leaves push upward toward light. Roots push downward, absorbing water and nutrients and anchoring the plant.

4 *Flower development.* The plant gradually shifts its emphasis from stem and leaf growth to reproduction, developing flowers.

5 *Pollination.* Pollen grains contain male genetic information, equivalent to sperm. Insects transfer pollen from one flower to another. If pollen is deposited on the receptive female part, called the *pistil,* the flower is fertilized and produces seeds.

6 *Seed development.* Seeds grow inside the pistil, which eventually becomes the seedpod or fruit.

Protect Those Pollinators!

More than 80 percent of the world's flowering plants need insects or animals for *pollination,* the process by which plants reproduce. Bees, beetles, butterflies, moths, and flies are some of the best insect pollinators there are. Bats and hummingbirds are also very valuable for pollination. Without these insects and animals, production of fruits, vegetables, and nuts — foods we depend on to survive — would be threatened.

That's why we always encourage people to garden responsibly. Here are two important ways to protect the pollinators in your garden.

LIMIT OR DISCONTINUE YOUR USE OF INSECTICIDES. Some of these poisons can kill not only the targeted insect pests they were formulated to eliminate, but also butterflies, honeybees, and other vital pollinators. Insecticides can make all parts of a plant toxic, including the nectar.

AVOID FILLING YOUR GARDEN WITH HYBRID PLANT SPECIES. Many hybrid flowers are genetically altered or selectively bred to produce certain colors, bloom sizes, or other traits. Unfortunately, this may result in flowers that have no pollen, nectar, or fragrance — the very things that insects and hummingbirds require.

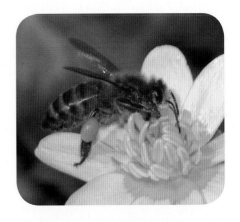

▲ Honeybees can fill the pollen baskets on the sides of their hind legs in just a few minutes. They bring the pollen back to their nest to use in making honey.

▼ Many insects transport pollen from one plant to another as they search for nectar. The transfer of pollen enables the plants to make seeds.

SOIL LIFE CYCLES

Believe it or not, even the soil in your garden has a life cycle. The more you understand it, the better soil you'll have, and the better gardener you're likely to be. By "soil," we mean *topsoil*, the layer of earth that contains the nutrients and organic materials needed to produce vigorous, healthy plants. Many life-forms play a role in producing topsoil.

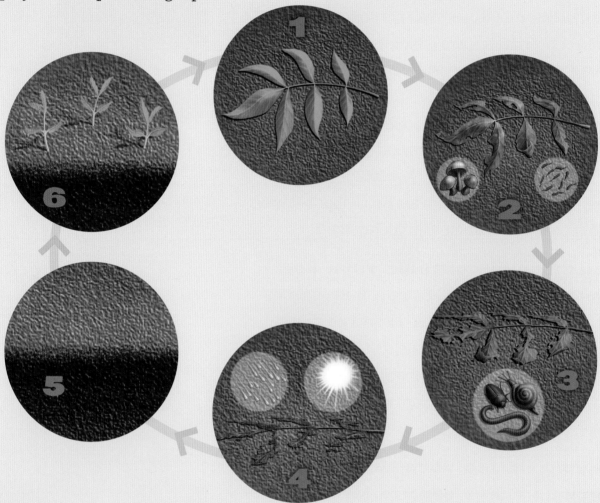

1 *A plant dies.*

2 *Microbes move in.* The decomposition process begins immediately. *Microbes* are microscopic organisms, such as fungi and bacteria, that attack and break down organic matter.

3 *Decomposers go to work.* Insects, snails, slugs, and worms also work on the dead plant, helping decompose it as it passes through their digestive tracts.

4 *Water and warmth contribute.* Rainfall and warm temperatures support and speed the decomposition process.

5 *The plant becomes soil.* Separated into various nutrients and organic particles, also called *compost*, the plant is now completely broken down.

6 *The soil supports new life.* Compost enriches the soil for future plants, and the cycle continues.

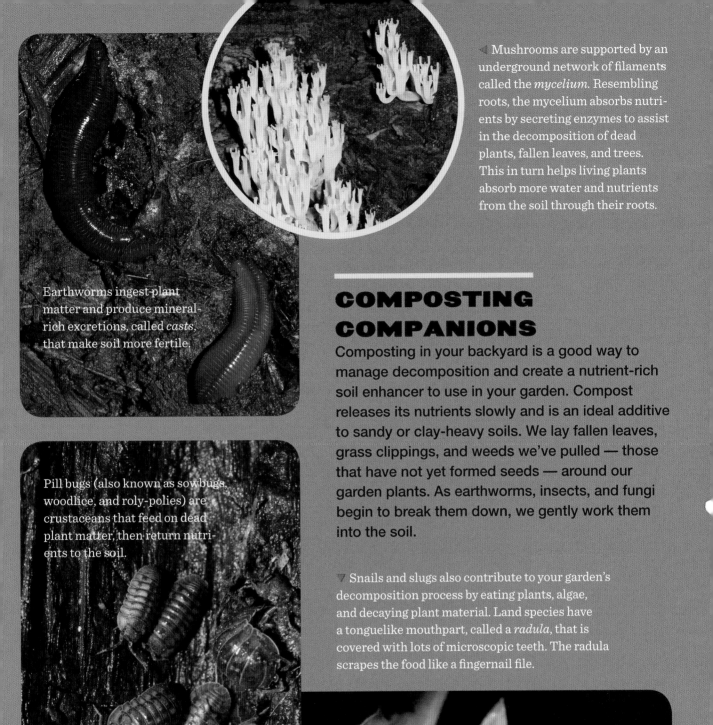

Mushrooms are supported by an underground network of filaments called the *mycelium*. Resembling roots, the mycelium absorbs nutrients by secreting enzymes to assist in the decomposition of dead plants, fallen leaves, and trees. This in turn helps living plants absorb more water and nutrients from the soil through their roots.

Earthworms ingest plant matter and produce mineral-rich excretions, called *casts*, that make soil more fertile.

Pill bugs (also known as sowbugs, woodlice, and roly-polies) are crustaceans that feed on dead plant matter, then return nutrients to the soil.

COMPOSTING COMPANIONS

Composting in your backyard is a good way to manage decomposition and create a nutrient-rich soil enhancer to use in your garden. Compost releases its nutrients slowly and is an ideal additive to sandy or clay-heavy soils. We lay fallen leaves, grass clippings, and weeds we've pulled — those that have not yet formed seeds — around our garden plants. As earthworms, insects, and fungi begin to break them down, we gently work them into the soil.

Snails and slugs also contribute to your garden's decomposition process by eating plants, algae, and decaying plant material. Land species have a tonguelike mouthpart, called a *radula*, that is covered with lots of microscopic teeth. The radula scrapes the food like a fingernail file.

LIFE CYCLES OF INSECTS AND SPIDERS

There are more than 100,000 insect species in North America and more than 3,000 spider species. That means there's probably a lot of bug life to observe in your garden, whether it's a showcase of beds and borders or a small vegetable patch.

All these creatures go through several stages of growth during a complete life cycle. Some undergo *simple* or *incomplete metamorphosis*; others go through *complete metamorphosis*. Depending on which stage it's in when you find it, it can be difficult to tell the creature's final form. We've taken hundreds of photographs of insects and spiders in different life-cycle stages. You can use them to help you identify the creatures in your own garden, or choose plants that will attract the insects and spiders you prefer. (For more information about host plants, see pages 119–122.)

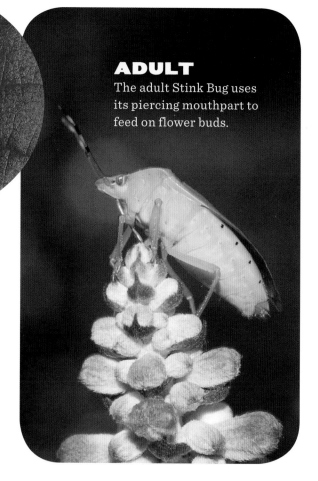

EGGS
▶ The adult Stink Bug lays her eggs in groups.

NYMPH
▼ The Stink Bug nymph has small undeveloped wings.

ADULT
The adult Stink Bug uses its piercing mouthpart to feed on flower buds.

Incomplete Metamorphosis

Incomplete metamorphosis has three stages: egg, nymph, and adult. Spiders, praying mantids, leafhoppers, and grasshoppers all go through incomplete metamorphosis. The female adult lays her eggs, usually in a mass and often covered by an egg case for protection. The eggs hatch into nymphs, which look like small adults and eat the same food as the adults. The nymphs slowly and steadily transform into the adult stage.

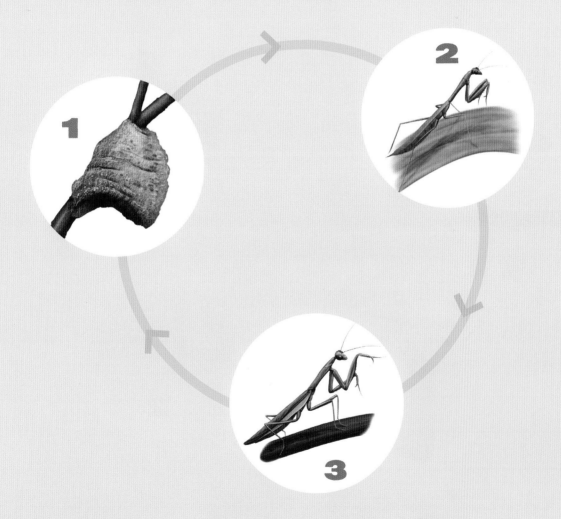

1 *Eggs.* The eggs are generally laid in a protected place with a ready food source.

2 *Nymphs.* The nymphs shed their skin generally 4 to 8 times (20 times for some insects) as they grow, but they always look like smaller versions of the mature adults.

3 *Adults.* Adults are larger, sometimes with better-developed wings. Adults do not molt.

Complete Metamorphosis

Complete metamorphosis has four stages: egg, larva, pupa, and adult. The female adult lays her eggs either singly or in groups, and the eggs hatch into larvae, which often look like worms. Other names for larvae are caterpillars (butterflies and moths), grubs (beetles), and maggots (flies). When they reach a certain size, the larvae stop eating and molt one more time. They may spin a protective silk cocoon, find a place to hide, or burrow into soft soil and then shed their skin to reveal the pupa stage, during which they transform into adults with wings.

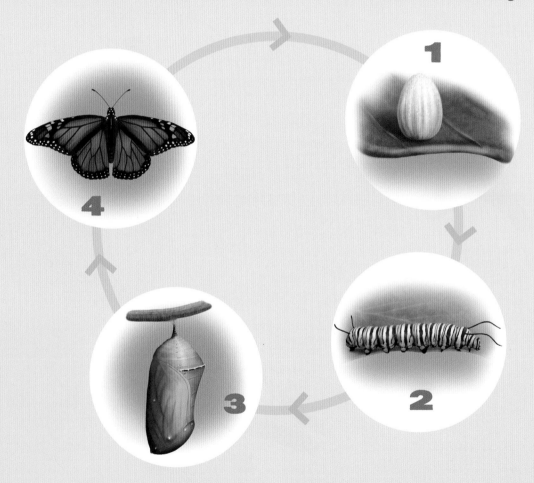

1 *Egg.* As with incomplete metamorphosis, insects lay their eggs in a protected place near a food source.

2 *Larva or caterpillar.* Active and hungry, insects at this stage can be destructive to human crops, structures, and belongings (Monarch butterfly caterpillars are not destructive, however). They shed their skin as they grow.

3 *Pupa.* During this stage, the insect doesn't feed or move around much, and it is often protected by a chrysalis shell or silk cocoon.

4 *Adult.* The adult insect emerges from its protective shell and looks completely different from the larval or pupal stage.

THE
SECRET LIVES OF
INSECTS
AND
SPIDERS

No matter where you live, insects and spiders live there too: in your garden, in your home, all around you. You might be tempted to think of these creatures as either "good" or "bad." Butterflies are beautiful and harmless and therefore must be "good"; Black Widow spiders are venomous and are therefore "bad." But try to remember that all are part of a healthy and balanced garden.

In the pages that follow, you can take a peek at the secret lives of some of the more common and easy-to-find garden dwellers. Their habits and skills are fascinating. We think that the more you know about them, the more you'll appreciate the interconnectedness of all living things.

Some spiders eat their damaged web and build a new one every day.

This Goldenrod Soldier Beetle is an insect, but not a true bug.

INSECT, BUG, OR WHAT?

Some people use the words *insect* and *bug* interchangeably, while others use *bug* to mean any tiny crawling thing with more than two legs. Let's try to set the record straight before we go any further!

An **insect** is an animal with a hard outer skeleton, called an *exoskeleton*, and a three-part body (head, thorax, and abdomen), three pairs of jointed legs, compound eyes, and two antennae.

A **bug** or **true bug** is a common name for the insect order called Hemiptera, meaning "half wings." Cicadas, aphids, Water Striders, Bedbugs, lacewings, and Stink Bugs are all examples of true bugs. All true bugs have mouthparts that enable them to pierce plant fibers, insects, or animal skin and suck their juices. Thus, all true bugs are insects but not all insects are true bugs.

Spiders are neither insects nor true bugs; they are *arachnids*. Nearly all arachnids have eight legs and two body divisions, and they never have antennae or wings.

There, does that help?

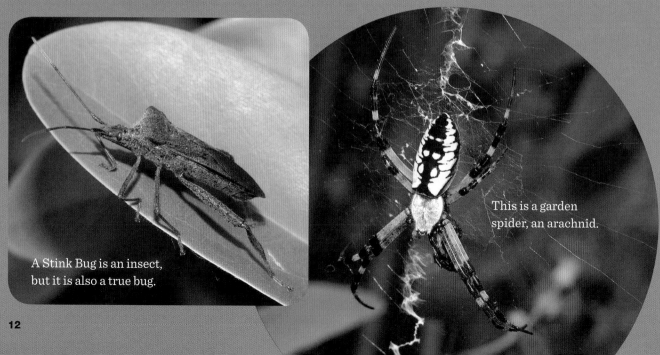

A Stink Bug is an insect, but it is also a true bug.

This is a garden spider, an arachnid.

About Beetles

Beetles make up more than a third of all known insect species. There are hundreds of thousands of beetle species, in seemingly infinite variations of shapes and colors, all over the world.

All beetles have chewing mouthparts; some eat plants; some are predators of insect pests; some are scavengers of animal and plant debris; and others are beneficial pollinators of flowers and crop plants. They're also a good source of food for birds, animals, and other insects.

All beetles go through complete metamorphosis: their larvae don't look at all like their adult forms, and all go through a pupal stage before emerging, transformed. All adults have hardened wings that cover the top of their body and meet in a straight line down their back.

GROUND BEETLES

Ground beetles live in damp habitats and are generally active predators at night. You can tell them from other beetles by the grooves etched on their wing covers. They eat worms, snails, and other insects.

◀ The large, colorful Fiery Searcher Beetle (*Calosoma scrutator*), sometimes called the "caterpillar hunter," eats Gypsy moth caterpillars and Eastern tent caterpillars. Because these caterpillars are destructive to trees, the Fiery Searcher is very beneficial.

LEAF BEETLES

Leaf beetles spend their lives munching on various plants. We call them beneficial when they eat weeds; we call them pests if they nibble on our vegetables or prize roses. Leaf beetles are distinguished by their metallic, bright-colored *elytra* (hard front wings) and short antennae. They're generally very small, less than half an inch long.

▲ The Dogbane Leaf Beetle is a small insect with shiny colors like metallic blue, green, and gold. It eats the leaves of dogbane and milkweeds.

LIGHTNING BUG
OTHER NAME: FIREFLY

Order: Coleoptera

By far the coolest bug in the garden, this glowing wonder brings back happy childhood memories. Do you see fewer of them these days? If so, it's probably because development is eating up their habitat.

EGGS

▶ Each summer, females lay one brood just under the surface of the soil. The tiny white eggs — each about the size of a single numeral on a penny — hatch in a few weeks.

LARVA

◀ When newly hatched, the larvae live and tunnel near the surface of the soil, eating slugs, worms, and snails. When disturbed, they curl up in a ball and play dead.

▼ They grow slowly all summer and into the fall. Even when fully grown, they're usually too small to notice by chance.

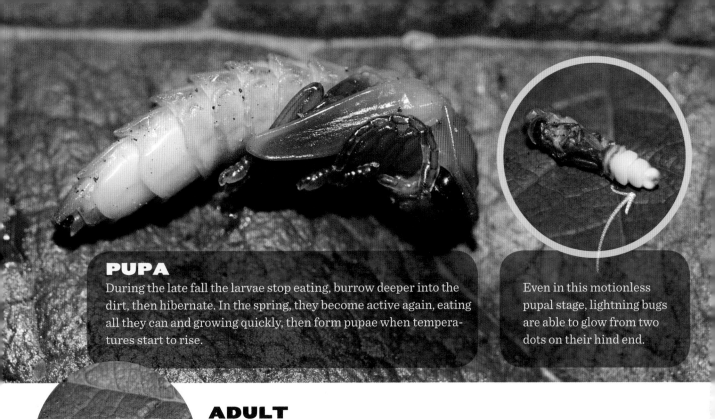

PUPA

During the late fall the larvae stop eating, burrow deeper into the dirt, then hibernate. In the spring, they become active again, eating all they can and growing quickly, then form pupae when temperatures start to rise.

Even in this motionless pupal stage, lightning bugs are able to glow from two dots on their hind end.

ADULT

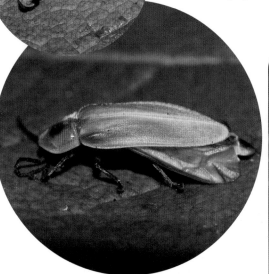

◀ When warm summer weather arrives, the lightning bug emerges from its pupal shell.

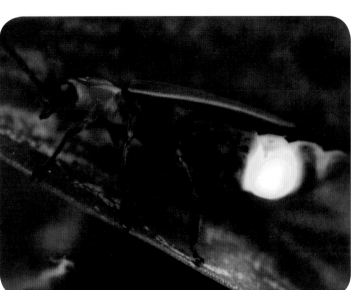

▲ At first the lightning bug is pale colored, and its delicate-membrane wings stick out from protective covers.

▶ As they dry and harden, the outer wings develop their familiar black color. Their glow is bright and fully developed.

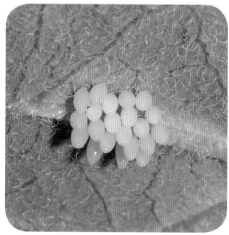

LADYBUG
OTHER NAMES: LADY BEETLE, LADYBIRD, LADYCLOCK, LADYFLY, LADYCOW

Order: Coleoptera

The ladybug is one of the best loved and most recognizable of all garden insects. There are more than 450 ladybug species in North America, and their shells, spotted and unspotted, can be yellow, pink, red, orange, or black. Ladybugs are favored by gardeners because both their larval and adult beetle forms gorge themselves on aphids, mites, scale insects, and other pests. Many cultures consider ladybugs good luck, and some believe that they are endowed with the ability to grant wishes.

HOST PLANTS Any preyed upon by aphids, such as some tomato plants

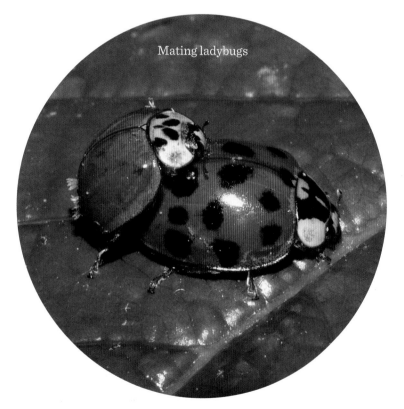

Mating ladybugs

EGGS

◀ Ladybugs may produce five or six generations of offspring in a year.

▼ Laid in clusters of 5 to 30, the eggs hatch in three or four days. To give the larvae a ready food source, the female chooses plants frequented by aphids or other insects.

LARVA

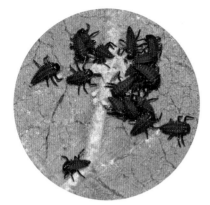

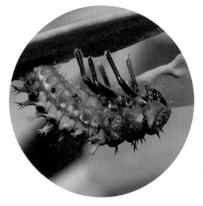

▲ At first the newly hatched larvae look like tiny spiders. They eat their empty egg cases as their first meal, and shed their skin several times as they grow.

▲ Ladybug larvae are always hungry, feeding on aphids or other insects on their host plant. As they mature, they start to look more like orange-and-black alligators.

▲ In two weeks, a larva reaches maturity and is ready to form a pupa.

PUPA

▶ The pupa attaches itself to a leaf and remains dormant for about a week.

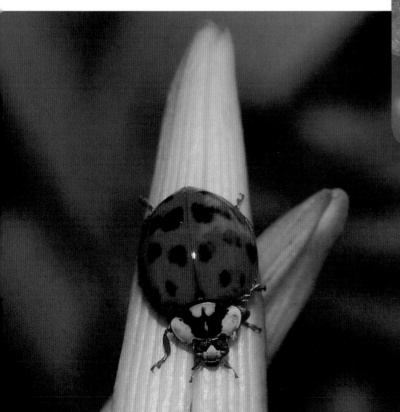

ADULT

Adult ladybugs overwinter in groups huddled together in sheltered areas. They sometimes make use of an interesting defense mechanism called *reflex bleeding*. When they feel threatened, they can leak yellow blood from around their leg joints. The liquid smells bad and contains an alkaloid toxin that apparently tastes nasty to predators.

CLAVATE TORTOISE BEETLE

Plagiometriona clavata

Last summer we were amazed to discover what looked like tiny turtles feeding on a woody nightshade plant, *Solanum dulcamara*, in the far corner of our yard. On closer inspection we also found little creatures with fleshy spines all around the sides of their bodies. After a bit of research, we learned that our plant was hosting the Clavate Tortoise Beetle, a species of leaf beetle.

Tortoise Beetle larvae and adult beetles eat the same host plants. Because nightshade is a weed, these beetles are considered beneficial and important in controlling its spread.

HOST PLANT Woody nightshade (*Solanum dulcamara*)*

LARVA

◄ The larva uses a "fecal fork" structure on its rear end to carry a protective shield of discarded molted skins and fecal matter. The larva can snap the shield over its back to deter predators.

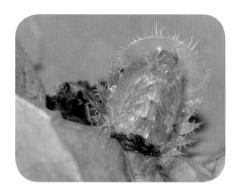

PUPA

▲ When ready to pupate, the Tortoise Beetle larva attaches itself to a leaf by its rear end. It will sometimes appear to "sit up" when disturbed. Within a week, its metamorphosis to adult beetle is complete.

ADULT

It's pretty obvious how the Tortoise Beetle got its name. Not only does it look like a miniature version of a turtle, but it will also pull in its feet and antennae if it senses a threat, just as a turtle will retreat into its shell. These beetles overwinter as adults, emerging in spring to feed and lay eggs.

FALSE POTATO BEETLE

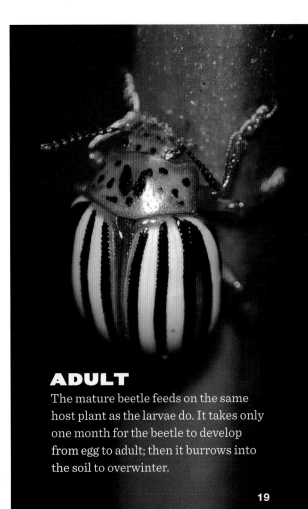

Leptinotarsa juncta

For several years we spotted the False Potato Beetle in its immature stage and thought it was going to turn into a ladybug. After all, the reddish pupa had black spots, was a similar size and shape, and was definitely a beetle. One day we saw the grub chewing on the leaves of a nightshade plant (*Solanum dulcamara*). We cut the stem, put it in a plastic container in the house, and took photos of the beetle as it matured.

And guess what? What emerged from the pupa several days later turned out to be a False Potato Beetle, not a ladybug. It looked almost exactly like its infamous relative the Colorado Potato Beetle, except it had an extra brown stripe between the black ones.

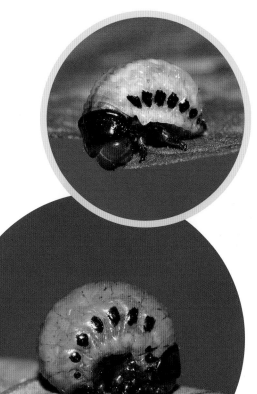

LARVA
◀ So plump we call it "hunchback," the False Potato Beetle larva is pale whitish with just a hint of pink, and has one row of black dots and a shiny, sluglike appearance. We can sometimes find them eating in groups.

PUPA
◀ The larva pupates by turning a dark pinkish red and becoming inactive for up to a week.

ADULT
The mature beetle feeds on the same host plant as the larvae do. It takes only one month for the beetle to develop from egg to adult; then it burrows into the soil to overwinter.

DRAGONFLIES

Order: Odonata

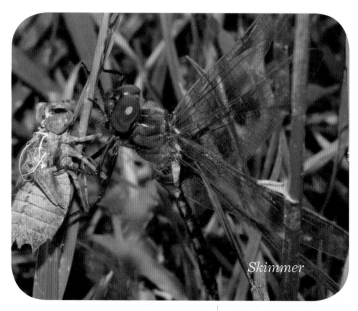

Although these nimble insects may look scary, rest assured that they cannot bite or sting you as adults. They spend the first two or three years of their lives underwater in a wingless nymph form, eating everything from mosquito larvae to small fish and tadpoles. That's when they *can* bite you, if you handle them.

Once this stage is over, dragonflies crawl out of the water and molt to reveal their new, winged look. This is the part of their life cycle you may be familiar with: you've probably watched them fly around ponds and gardens looking for food. They are considered beneficial garden predators, consuming lots of mosquitoes every day. As adults, dragonflies mate in midair and live for a few weeks or months at most.

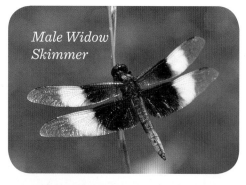

Male Widow Skimmer

◀ Among the fastest-flying insects in the world, dragonflies can hover and also move rapidly sideways and backwards.

▼ One of the better-known myths about dragonflies — and there are many — is that they can bring dead snakes back to life; this is where they got the nickname "snake doctors." Here a dragonfly dries its wings next to a discarded nymph case.

Skimmer

▲ The dragonfly uses its six legs mainly for holding on to things rather than for walking.

Skimmer

DRAGONFLY OR DAMSELFLY?

It's easy to confuse dragonflies and damselflies. Both have long, slender bodies, two sets of transparent wings that can move independently, compound eyes, and short antennae. They're both day fliers, of many different sizes and colors, with a variety of patterns and markings on their wings and bodies. Here are some ways to tell the difference.

While at rest, dragonflies hold their wings straight out from their bodies, as if they were tiny airplanes ready to take off. They bask in the sun, regulating their body temperature by adjusting their position to absorb heat.

A dragonfly's eyes almost always meet in the middle; a damselfly's do not. Dragonflies have fantastic eyesight; their compound eyes' thousands of facets are arranged to give them an almost 360-degree field of vision.

Male Blue Dasher Dragonfly

Notice the damselfly's wide-set eyes.

Narrow-winged Damselfly

DAMSELFLIES

Order: Odonata

Damselflies are smaller in size and weaker fliers than
dragonflies, but they go through incomplete metamorphosis,
just as dragonflies do, usually over the course of one year. The
female damselfly lays her eggs on plants just below the waterline or on
vegetation hanging over water. Underwater, after hatching, the predatory
damselfly nymph (also called a *naiad*) feeds on tadpoles, insects, and small
fish, going through a series of between nine and twelve *instars* (growth periods
between molts) before emerging on land for a final molt.

You can find damselflies around the small lakes, ponds, and prairie gardens
where their food likes to hide. We've found many around the slow-running creeks
near our gardens.

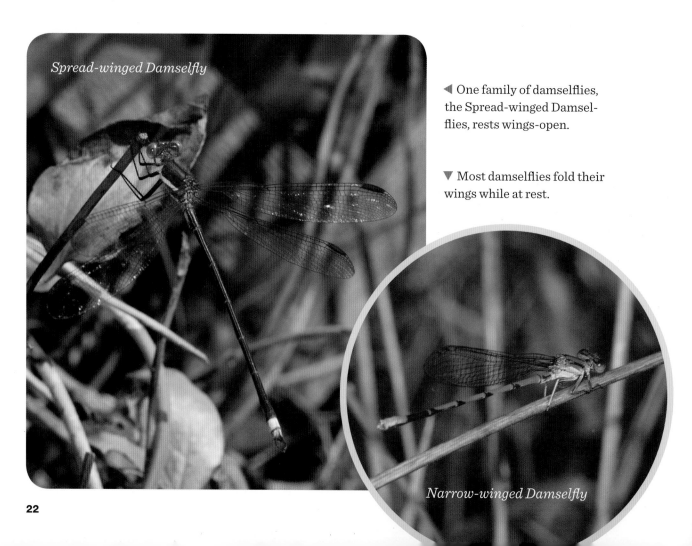

Spread-winged Damselfly

◀ One family of damselflies,
the Spread-winged Damsel-
flies, rests wings-open.

▼ Most damselflies fold their
wings while at rest.

Narrow-winged Damselfly

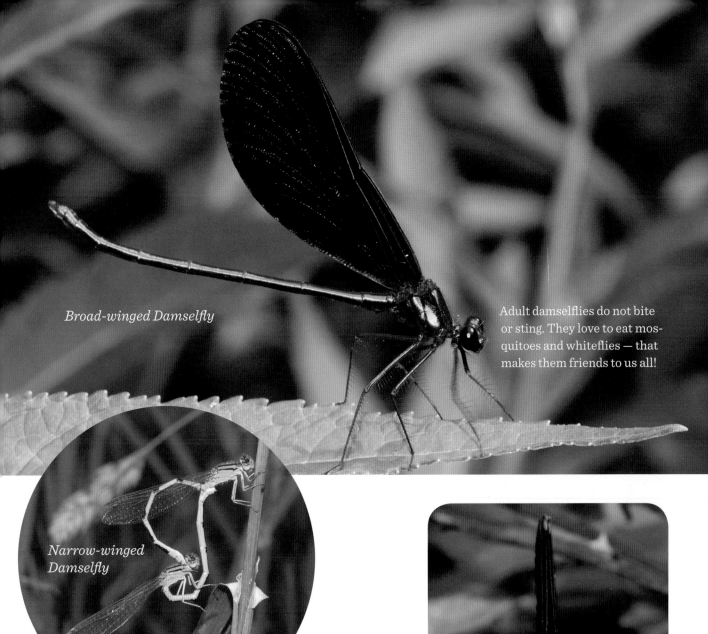

Broad-winged Damselfly

Adult damselflies do not bite or sting. They love to eat mosquitoes and whiteflies — that makes them friends to us all!

Narrow-winged Damselfly

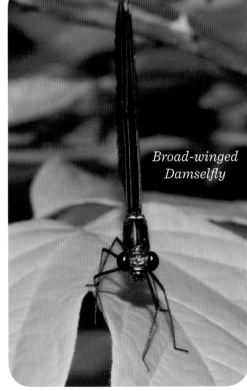

Broad-winged Damselfly

▲ Damselfly pairs form a heart shape known as *the wheel* when mating, usually while sitting on a plant. The damselfly male clasps the female behind the head; she curls her abdomen up to pick up sperm from the male's second abdominal segment.

▶ In our experience, the delicate damselflies are less timid than dragonflies and easier to approach. The Broad-winged Damselfly is commonly found near streams.

GREEN LACEWING
OTHER NAME: APHID LION

Order: Neuroptera

Lacewings remind us of miniature dragonflies. They have long, slender bodies and delicate, transparent wings crisscrossed with intricate vein patterns. They are more active at night; we often find a couple of them clinging to our screen doors early in the morning.

Consumers of pollen, nectar, and sometimes tiny insects, lacewings are also known to eat *honeydew*, a sugary liquid secreted by aphids as they feed on plant sap. Under pressure inside the plant, the sap shoots out when an aphid pierces the leaf or stem, passing right through its gut and out the other end.

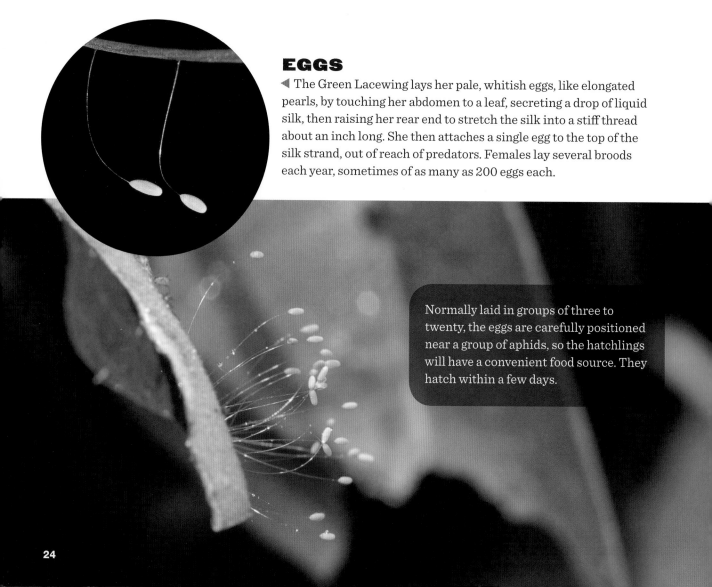

EGGS
◀ The Green Lacewing lays her pale, whitish eggs, like elongated pearls, by touching her abdomen to a leaf, secreting a drop of liquid silk, then raising her rear end to stretch the silk into a stiff thread about an inch long. She then attaches a single egg to the top of the silk strand, out of reach of predators. Females lay several broods each year, sometimes of as many as 200 eggs each.

Normally laid in groups of three to twenty, the eggs are carefully positioned near a group of aphids, so the hatchlings will have a convenient food source. They hatch within a few days.

LARVA

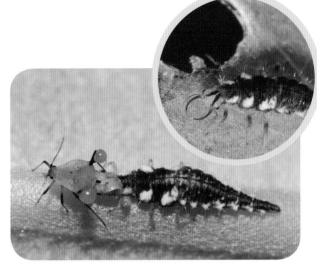

▲ Like a mere speck of fluff when it first emerges, the Green Lacewing larva quickly becomes a merciless predator. It sheds its skin several times as it grows.

▲ For two or three weeks, the Green Lacewing larva eats aphids (*shown here*), whiteflies, spider mites — and sometimes its own siblings. It pierces the soft bodies of its victims and sucks out internal juices through its hollow jaws. Lacewing larvae are often used in orchards, greenhouses, and conservatories to control plant pests.

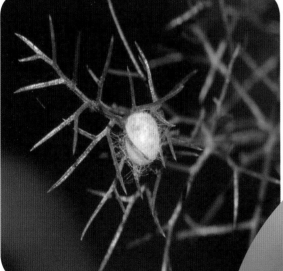

PUPA

◀ To survive the winter months, the mature Green Lacewing larva encases itself in a small round cocoon spun from silk. Usually positioned under a leaf, loose bark, or soil, it resembles a spider's egg sac.

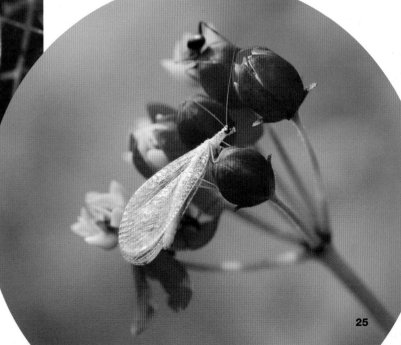

ADULT

▶ The adult emerges in early spring, its intricate wings shimmering like pale stained glass in the right light. Those wings are more beautiful than functional, however: lacewings are weak fliers.

HOVERFLIES
OTHER NAME: FLOWER FLIES

Order: Diptera

These adorable little insects are marked like bees or wasps and can easily be mistaken for them. The best way to tell the difference is to count their wings. Like all flies, hoverflies have just one pair of wings; bees have two pairs. Hoverflies also have stubbier antennae than wasps or bees.

Fast flying and able to hover over flowers, hoverflies also have the rare ability to fly backwards. As adults, they spend their days feeding on nectar, which makes them important pollinators for food crops such as carrots, onions, and fruit trees. As larvae, certain species are important predators of plant-sucking aphids. Some gardeners plant mint, daisies, and chamomile to attract hoverflies, as they'll lay their eggs on aphid-infested plants.

EGGS

▼ One by one, the hoverfly lays her eggs on an aphid-covered plant. The eggs hatch in about three days.

LARVA

▶ Smooth, legless, and wormlike, with pointed heads, hoverfly larvae are also called *maggots*. Although they look meek enough, they begin their lives as predators almost immediately.

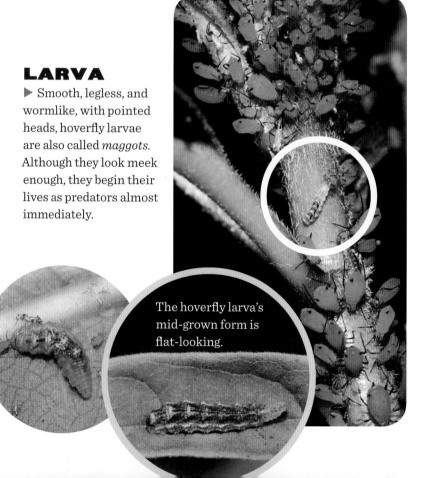

The hoverfly larva's mid-grown form is flat-looking.

▶ By the time the larva is fully grown, it can eat 50 or 60 aphids and other plant-sucking insects every day. It grabs its prey, pierces it with its jaws, raises it in the air, then drains it of its bodily fluids. It feeds this way for a week or more.

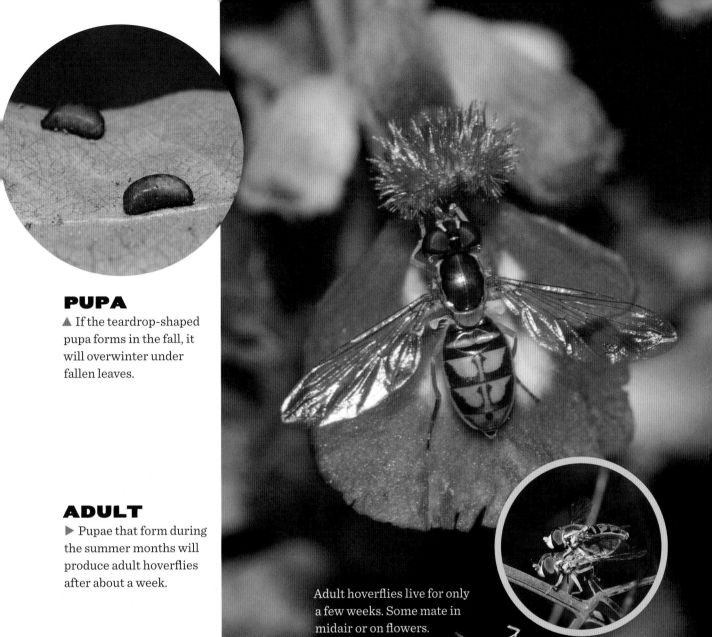

PUPA

▲ If the teardrop-shaped pupa forms in the fall, it will overwinter under fallen leaves.

ADULT

▶ Pupae that form during the summer months will produce adult hoverflies after about a week.

Adult hoverflies live for only a few weeks. Some mate in midair or on flowers.

DON'T SWAT SWEAT BEES!

Our grandmother always called hoverflies "sweat bees," because they'd follow us around in the summertime and land on us to get moisture from our sweat. To add to the confusion of identifying them, there actually are some little bees (see page 34) that also like to land on sweaty people to get moisture. So don't smack at them. If it *is* a bee instead of a harmless hoverfly, it can give you a small sting to defend itself.

STICK INSECTS
OTHER NAMES: WALKINGSTICK, STICK BUG, DEVIL'S DARNING NEEDLE

Order: Phasmida (Phasmatodea)

For years we were convinced that stick insects were not native to our area: We considered ourselves well aware of the wildlife in our gardens, and we'd never seen one. Then one day, as we were taking pictures of a large spiderweb in a butterfly bush, we saw a stick slowly walking along a branch. We could hardly believe our eyes. Its stealthy movements and cryptic coloring enabled it to blend in perfectly with its surroundings. We later learned that stick insects are mainly nocturnal and spend the day hiding motionless under plant leaves. No wonder it took us so long to see one!

Stick insects undergo an incomplete metamorphosis with three stages: egg, nymph, and adult. The females are said to let their eggs fall into leaf litter on the ground, where they overwinter. According to our research, some species' females don't need males to reproduce — they can lay eggs containing clones of themselves through a reproductive process called *parthenogenesis*. In the spring, the nymphs hatch from their eggs and molt several times as they grow; by summer, they are mature adults.

HOST PLANTS Blackberry brambles; black locust, oak, and wild cherry trees

▶ Most stick insects look just like the twigs they live among. Nymphs and adults feed on tree and shrub leaves at night.

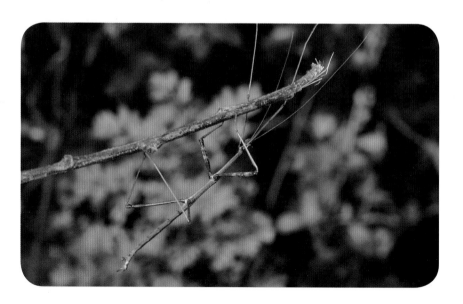

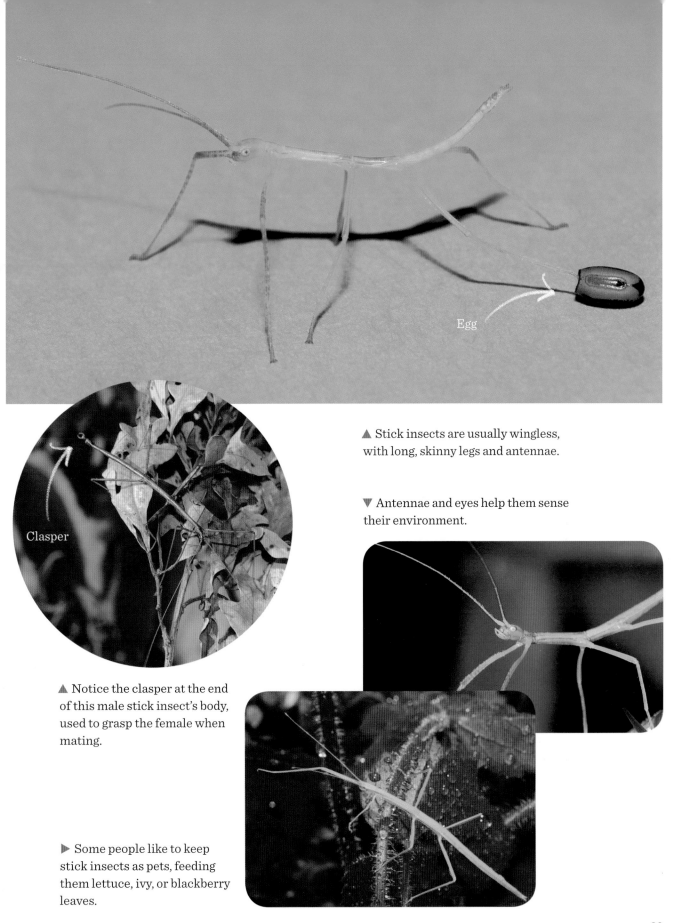

Egg

Clasper

▲ Stick insects are usually wingless, with long, skinny legs and antennae.

▼ Antennae and eyes help them sense their environment.

▲ Notice the clasper at the end of this male stick insect's body, used to grasp the female when mating.

▶ Some people like to keep stick insects as pets, feeding them lettuce, ivy, or blackberry leaves.

CHINESE MANTID

Tenodera sinensis

To most gardeners, the mantid is a well-known visitor. There are hundreds of species, but one of the largest is the nonnative Chinese Mantid, a type of Praying Mantid, introduced to North America in the late 1800s for pest control. The Chinese Mantid can grow to a length of more than six inches, and is easy to distinguish from native varieties, which are only about half as long when fully grown.

The mantid, the lion of the insect world, is at the top of the food chain: It will eat just about anything that gets too close. Mantids are an important part of a balanced garden, but you must understand that they'll eat your favorite insects — like butterflies — as well as your least favorite ones, if they get the chance.

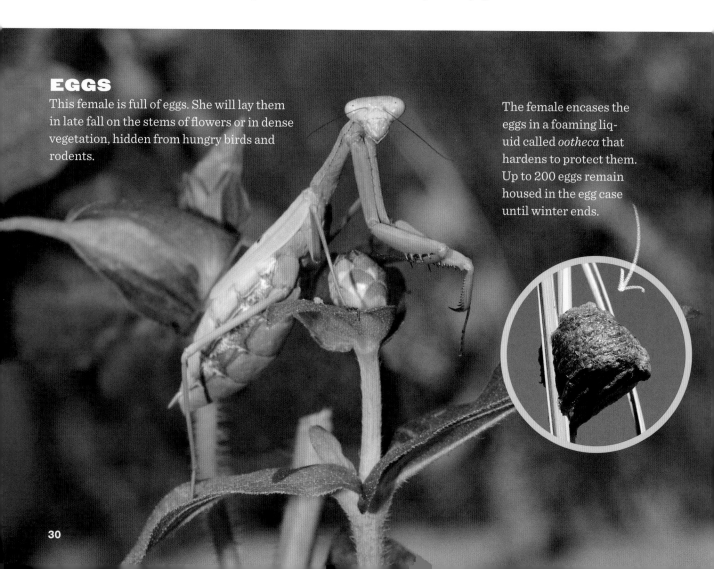

EGGS

This female is full of eggs. She will lay them in late fall on the stems of flowers or in dense vegetation, hidden from hungry birds and rodents.

The female encases the eggs in a foaming liquid called *ootheca* that hardens to protect them. Up to 200 eggs remain housed in the egg case until winter ends.

NYMPH

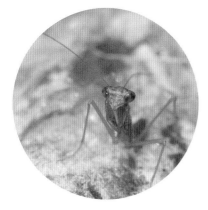

▲ After about a month of consistent warm weather, the nymphs emerge through narrow slits in the egg case, ready to go hunting for their first meal.

▲ The mantid nymph will eat anything it can grab and hold with its powerful front legs.

▲ The nymph molts up to ten times before it is fully grown.

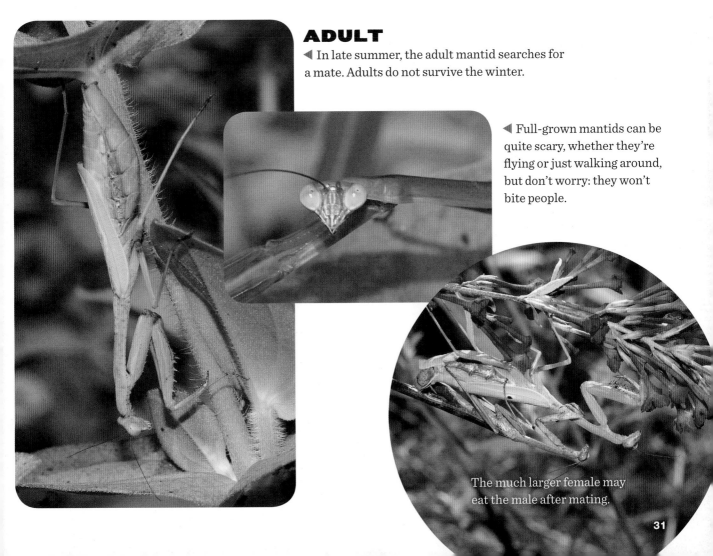

ADULT

◀ In late summer, the adult mantid searches for a mate. Adults do not survive the winter.

◀ Full-grown mantids can be quite scary, whether they're flying or just walking around, but don't worry: they won't bite people.

The much larger female may eat the male after mating.

WASPS

Order: Hymenoptera

While a wasp sting can be a scary thought, it might reassure you to know that most wasps are really very small — many are the size of gnats! — and there are only a few actively aggressive wasp species. The majority will sting only when they're disturbed.

Wasps form new colonies every year, starting in late spring when a queen emerges from hibernation and builds a nest where she can lay her eggs. After the first batch of eggs hatch, the queen feeds the larvae until they have pupated and emerged as sterile female adult workers. The queen then leaves the tending of the larvae to the workers and lays eggs until autumn, when she dies. Some of the eggs develop into male drones and fertile females, who mate at the end of summer. The males die almost immediately, whereas the females find a safe spot to over-winter, emerging as queens in late spring to start the cycle again.

The wasps shown here are just some of those we've seen in our gardens.

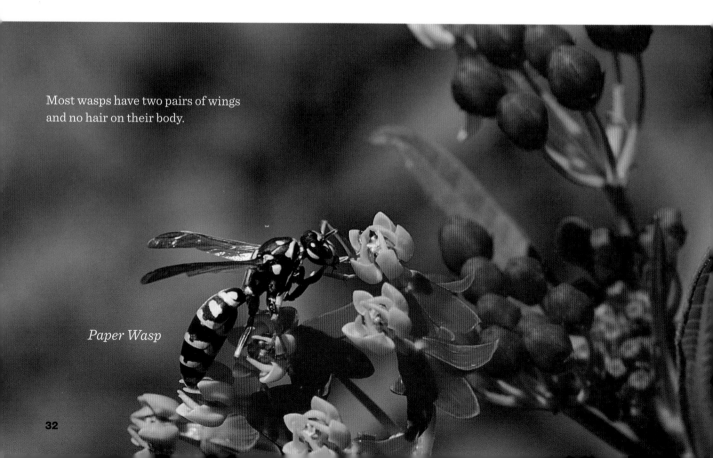

Most wasps have two pairs of wings and no hair on their body.

Paper Wasp

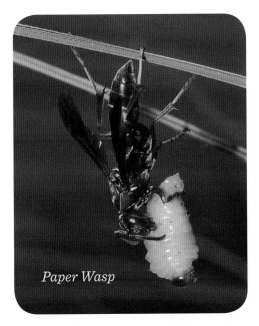

Paper Wasp

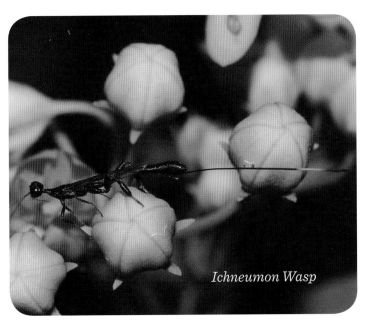

Ichneumon Wasp

▲ More and more wasps are being used for natural agricultural-pest control, because they eat many of the caterpillars that destroy crop plants. Here, a wasp devours what appears to be the pupa form of some other insect.

▲ This female wasp has a long *ovipositor*, an organ used to deposit eggs. It is not a stinger.

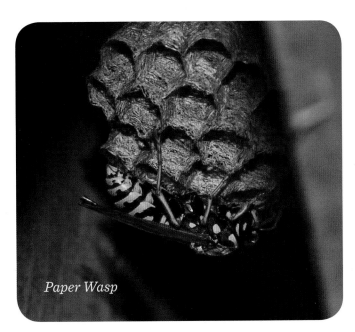

Paper Wasp

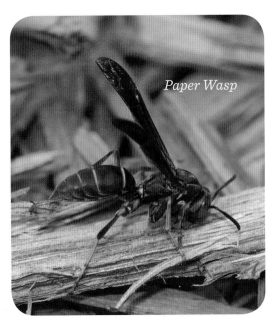

Paper Wasp

▲ Wasps do not have wax-producing glands, as bees do. They must chew wood fibers into pulp and use it to make hives with cells to raise their young.

▲ Paper Wasps collect wood and plant fibers and mix them with saliva to create the water-resistant paper they use to build their nests.

BEES

Order: Hymenoptera

Bees get a lot more respect than wasps, probably because they help humans more directly, providing honey and beeswax. They're industrious, too, working all day to gather nectar and pollen, using their long, complex tongue (called a *proboscis*) to reach into flowers.

The basic life cycles of bees have some similarities to those of wasps: the queen forms or builds a nest, lays eggs, cares for the first larvae herself until adult workers can take over, and then spends the rest of the summer laying additional eggs. Some of her female offspring become new queens, overwintering in a protected spot, while her male offspring mate and then die. Honeybees have a slightly different life cycle, as the queens live for two or three years and the colony does not disband in the autumn, but instead can continue indefinitely.

◀ Although their attraction to human sweat can make them a nuisance, sweat bees like this one are beneficial pollinators.

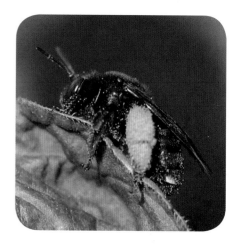

▲ Only female bees collect pollen. They have "baskets" on their hind legs or hair underneath their abdomen for pollen collection.

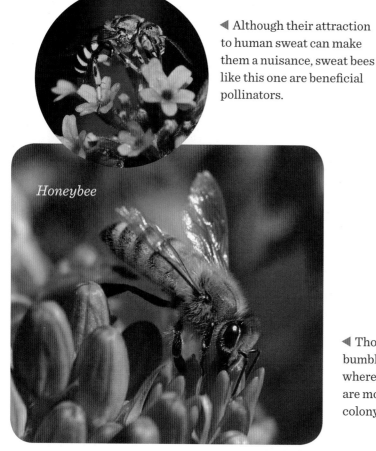

Honeybee

◀ Though most bees are solitary, honeybees and bumblebees are social, living in large colonies where they produce and store honey. Social bees are more likely to sting, usually in defense of the colony.

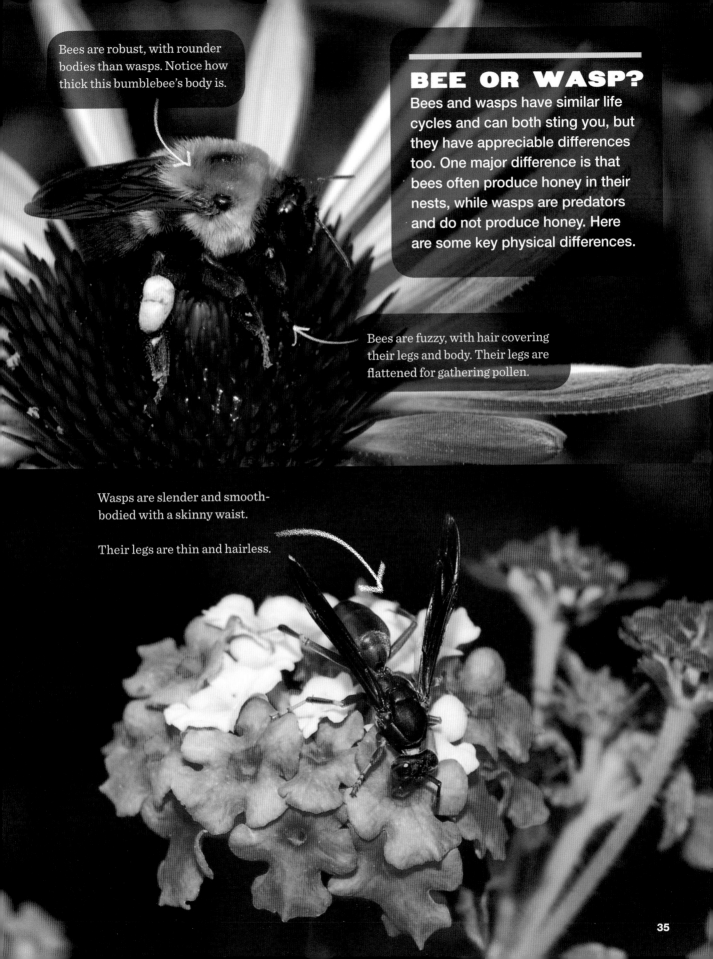

Bees are robust, with rounder bodies than wasps. Notice how thick this bumblebee's body is.

BEE OR WASP?

Bees and wasps have similar life cycles and can both sting you, but they have appreciable differences too. One major difference is that bees often produce honey in their nests, while wasps are predators and do not produce honey. Here are some key physical differences.

Bees are fuzzy, with hair covering their legs and body. Their legs are flattened for gathering pollen.

Wasps are slender and smooth-bodied with a skinny waist.

Their legs are thin and hairless.

ANTS

Order: Hymenoptera

Ants, in many different sizes and colors, seem to be just about everywhere. Their work in nature is vital: they clean up dead organisms on the forest floor and help control other insect populations. Some eat plants; others, meat.

Like some wasps and bees, ants are organized into groups known as armies or colonies, with a queen (who locates the nest and reproduces); a large worker population of sterile females; and white, legless larvae that molt as they grow. The queen lays her tiny eggs underground or in deadwood, and when they hatch they're fed by workers until they pupate. Males mate with the queen, and die soon after mating. Just as with honeybees, the ants you see in your garden are all females and do all the work.

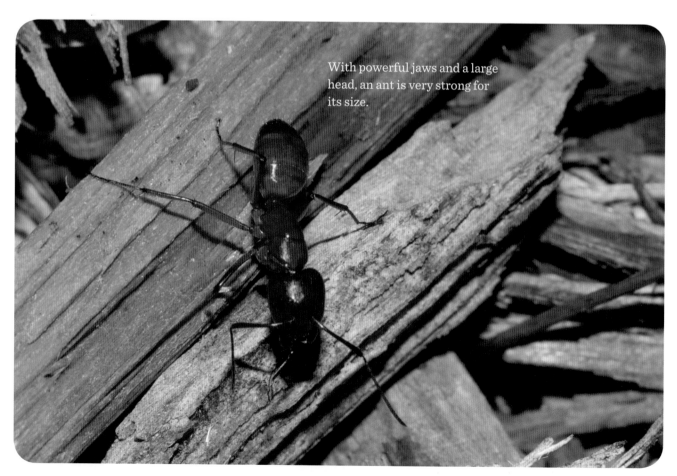

With powerful jaws and a large head, an ant is very strong for its size.

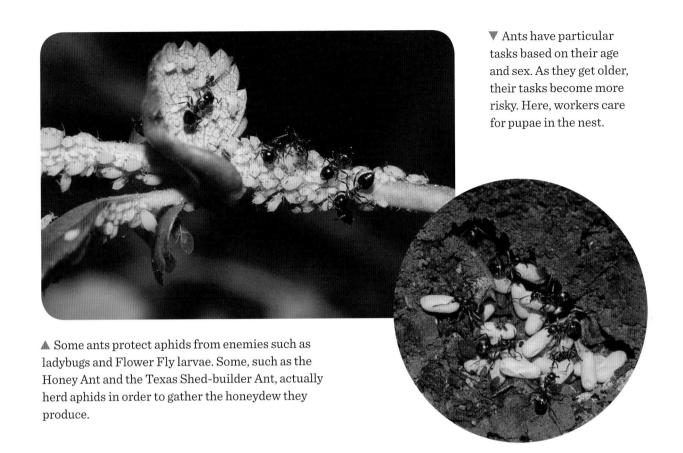

▼ Ants have particular tasks based on their age and sex. As they get older, their tasks become more risky. Here, workers care for pupae in the nest.

▲ Some ants protect aphids from enemies such as ladybugs and Flower Fly larvae. Some, such as the Honey Ant and the Texas Shed-builder Ant, actually herd aphids in order to gather the honeydew they produce.

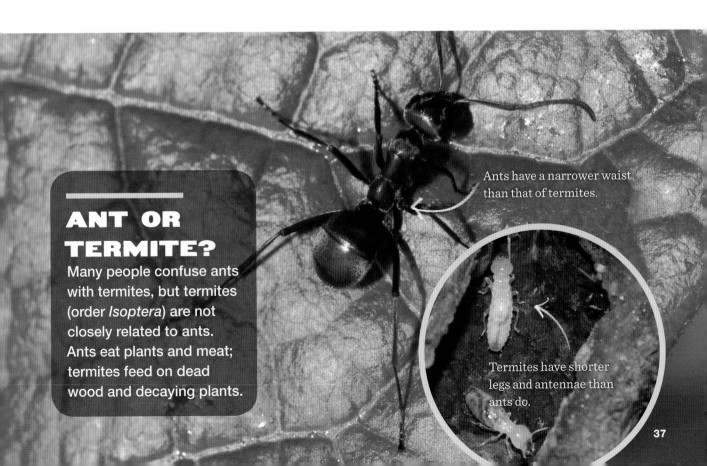

Ants have a narrower waist than that of termites.

ANT OR TERMITE?

Many people confuse ants with termites, but termites (order *Isoptera*) are not closely related to ants. Ants eat plants and meat; termites feed on dead wood and decaying plants.

Termites have shorter legs and antennae than ants do.

GRASSHOPPERS

Order: Orthoptera

Common in just about any garden, grasshoppers are easy to overlook until they're almost fully grown, usually in the mid- to late-summer months. You'll notice a multitude of different colors and patterns, as well as some with very long horns (antennae) and others with quite short ones.

When conditions are right, certain short-horned grasshoppers reproduce rapidly and form very large groups — sometimes in the billions — that can travel long distances, destroying enormous amounts of plant life. Grasshoppers in swarms like this are called *locusts*. Grasshoppers also serve as prey for birds, toads, lizards, and spiders. People around the world eat grasshoppers, too.

NYMPH

▶ Grasshoppers go through incomplete metamorphosis: nymphs hatch from eggs and molt several times before they reach adulthood. Nymphs and adults look very similar to one another, but young grasshoppers have no wings and do not develop them until later in life.

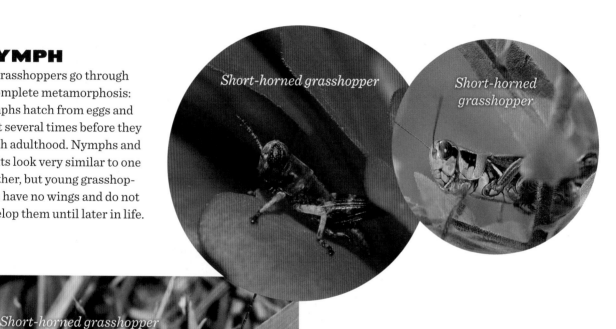

Short-horned grasshopper

Short-horned grasshopper

Short-horned grasshopper

ADULT

◀ Only adult males chirp, using what is called a *stridulating organ* located at the base of their wings. A grasshopper generally chirps to attract a female or to define his territory.

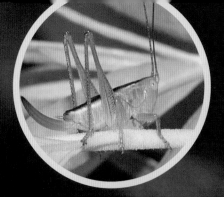

Long-horned grasshopper

Short-horned grasshopper

Grasshoppers are generally very well camouflaged, but when threatened they may spit a brown defense chemical — really a digestive liquid — commonly known as "tobacco juice."

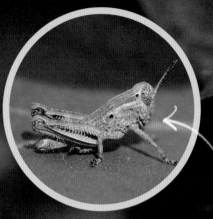

Grasshoppers of both sexes can jump about 20 times the length of their body.

Short-horned grasshopper

ORTHOPTERA TIMES THREE

Grasshoppers, katydids, and crickets are all members of the same order: Orthoptera. Insects in this order go through incomplete metamorphosis. Females use their long ovipositors to lay their eggs in the soil or on plant stems. Nymphs hatch from the eggs and go through a series of instars before they reach adulthood. Nymphs and adults look very similar to one another. And they all have those incredible springy hind legs!

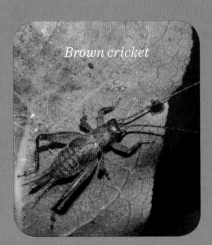

Brown cricket

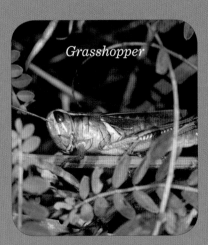

Grasshopper

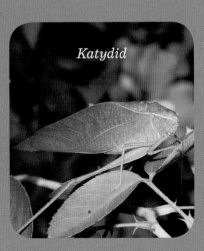

Katydid

KATYDIDS

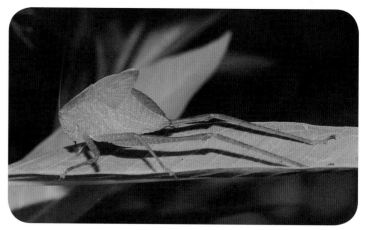

Order: Orthoptera

Katydids are really just large nocturnal versions of grasshoppers, although they look a little different. Adult katydids can fly and jump just like grasshoppers, and their excellent camouflage makes it hard to tell them from the leaves they're eating.

Unlike grasshoppers, both males and females can sing the unmistakable *Katy-did-Katy-didn't* song during the warm summer months. On very rare occasions, they are pink rather than that bright, dazzling green.

NYMPH

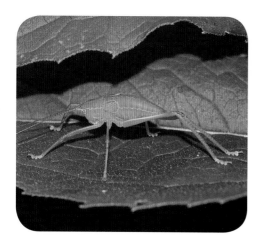

▲ Young katydids have very tiny wings.

▲ The wings of this older katydid are much larger.

ADULT

▶ Adults' wings extend the whole length of their body, and beyond.

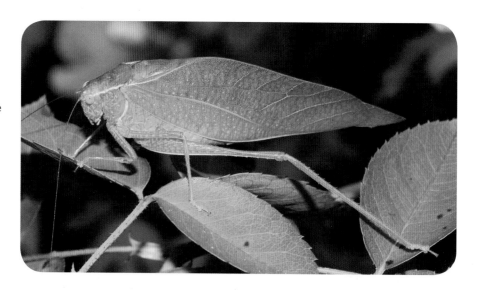

WHEN WAYNE MET A KATYDID

My first experience with a katydid was unforgettable. When I was about six, I found one at the bottom of my blue slushie. I took it back to the store and was told that it must have flown into the slush puppy machine during the night. Somehow that didn't make me feel any better. Judy thought it was very funny, though . . .

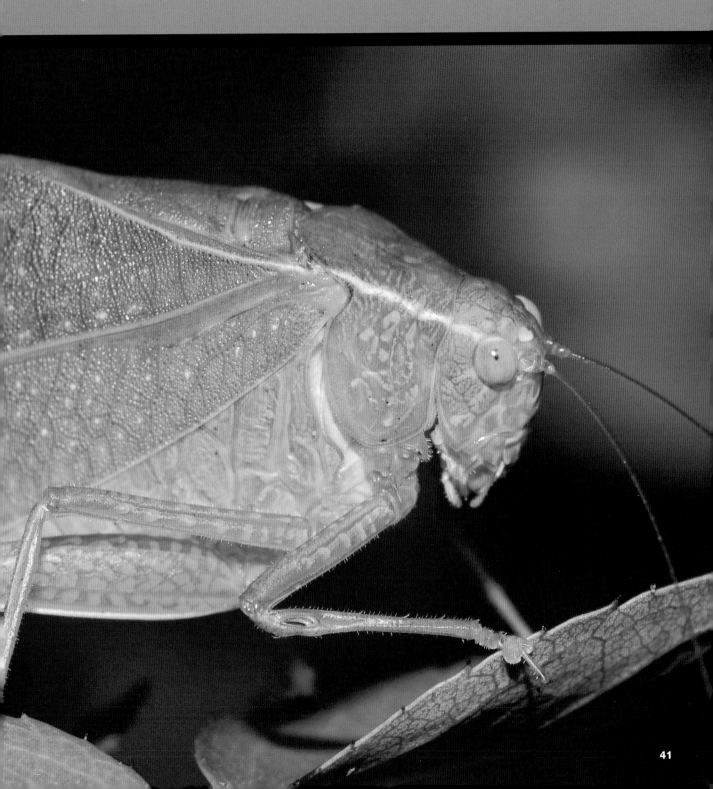

CRICKETS

Order: Orthoptera

Crickets are one of the most common insects you'll encounter in your garden. Just turn over any rock or old log, and we can almost guarantee that you'll send crickets hopping in all directions. They can be any of several different shades of black or brown and may look quite different from species to species. While crickets can bite (which feels more like a pinch), they'll usually just try to hop away.

Unlike grasshoppers, crickets prefer to hunt for food under cover of night. Their diet consists of plants, fungi, dead insects, and even — if food is in short supply — each other. Like grasshoppers, only the males make that unmistakable summer chirping sound.

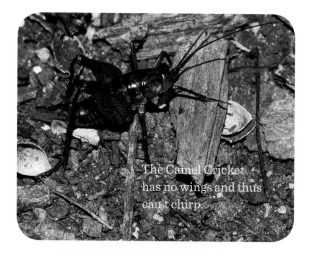

The Camel Cricket has no wings and thus can't chirp.

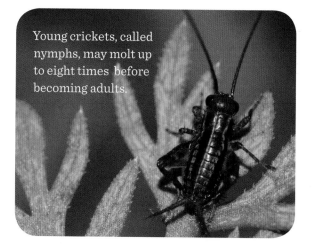

Young crickets, called nymphs, may molt up to eight times before becoming adults.

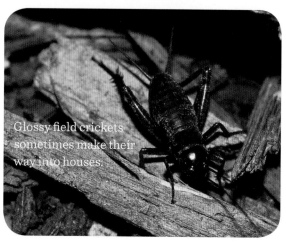

Glossy field crickets sometimes make their way into houses.

The Red-headed Bush Cricket has a particularly high-pitched chirp.

About the Order Hemiptera

Rarely the subject of fairy tales or songs, most insects of the order Hemiptera — which includes cicadas, aphids, Stink Bugs, Leafhoppers, and Spittlebugs — spend their lives feeding on plant sap. They all have mouthparts that pierce the stem or leaf tissue of plants; then, like tiny vampires, they drink the nutritious plant juice. They definitely do not endear themselves to those of us trying to grow gardens or food crops.

Insects in this order go through incomplete metamorphosis, from egg to nymph to adult.

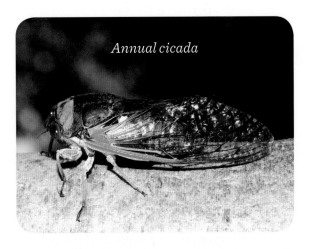

Annual cicada

▲ Cicadas spend most of their life underground as nymphs. Adults like this one are seen only for a couple of weeks each year as they look for mates and lay eggs.

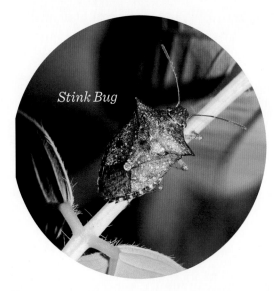

Stink Bug

▲ Stink Bugs, depending on the species, may feed on plants or they may be predators of other insects.

▼ Leafhoppers are generally considered to be pests because they feed on plant sap.

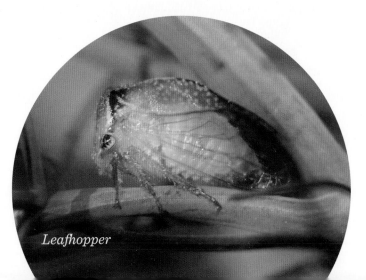

Leafhopper

CICADAS
OTHER NAMES: JULY FLIES, HEAT BUGS, DRY FLIES

Order: Hemiptera

If you ever experience one of the large periodical cicada broods some hot summer, you won't soon forget the deafening noise they make from the trees. Before you jump to the conclusion that this is one worthless insect, consider the fact that cicadas are food for birds, moles, toads, and other insects, including the Cicada Killer Wasp, and are eaten by humans in Asia, Latin America, and Africa. They're also one of the loudest insects in North America: the males make that characteristic clicking sound by vibrating their abdominal membranes.

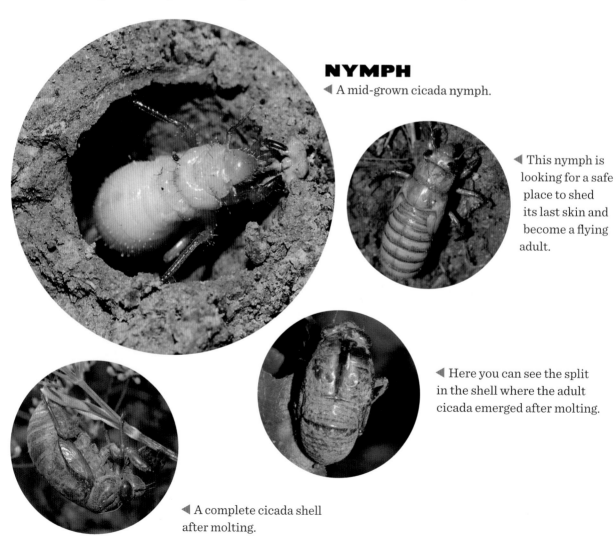

NYMPH
◀ A mid-grown cicada nymph.

◀ This nymph is looking for a safe place to shed its last skin and become a flying adult.

◀ Here you can see the split in the shell where the adult cicada emerged after molting.

◀ A complete cicada shell after molting.

ADULT

▶ Using her knifelike ovipositor, the female periodical cicada inserts her eggs into small tree branches and dies soon afterward. Once hatched, the newborn nymphs drop to the ground and burrow into the soil to feed on the juices of plant and tree roots. The nymphs shed their skin several times, growing larger and larger until they're ready to emerge, which can take 17 years. *Warning:* Cicadas are very clumsy fliers and will land on you or anything else in their way.

▶ Annual cicadas appear every summer. They're not harmful to people or pets, but egg-laying females can damage trees.

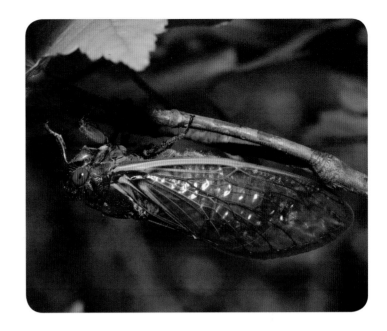

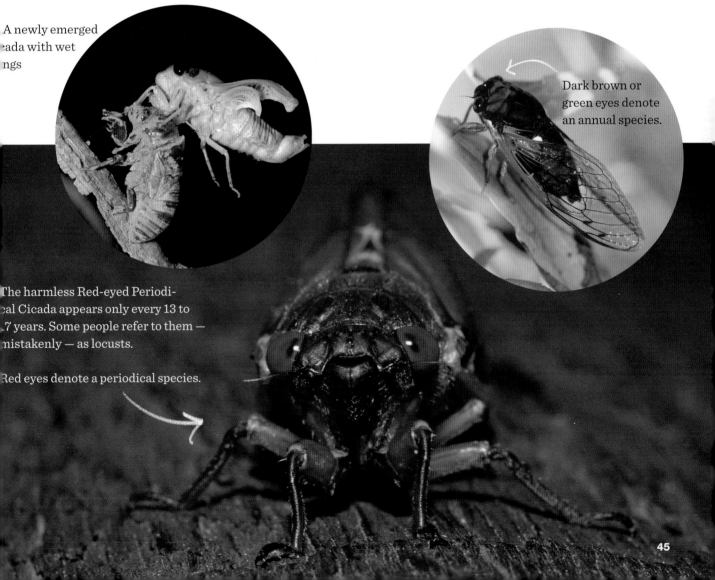

A newly emerged cicada with wet wings

Dark brown or green eyes denote an annual species.

The harmless Red-eyed Periodical Cicada appears only every 13 to 17 years. Some people refer to them — mistakenly — as locusts.

Red eyes denote a periodical species.

APHIDS
OTHER NAME: PLANT LICE

Order: Hemiptera

The aphids we generally see are bright orange and feed on milkweeds. All aphid species can reproduce at an alarming rate. Their spring and summer offspring are primarily females — some winged, some wingless — that give live birth to male or female clones of themselves. This type of "males-not-needed" reproduction is called *parthenogenesis*, or virgin birth. As winter approaches, some aphid females mate with males and lay eggs that overwinter. These eggs will hatch as females in the spring, guaranteeing a continuing population.

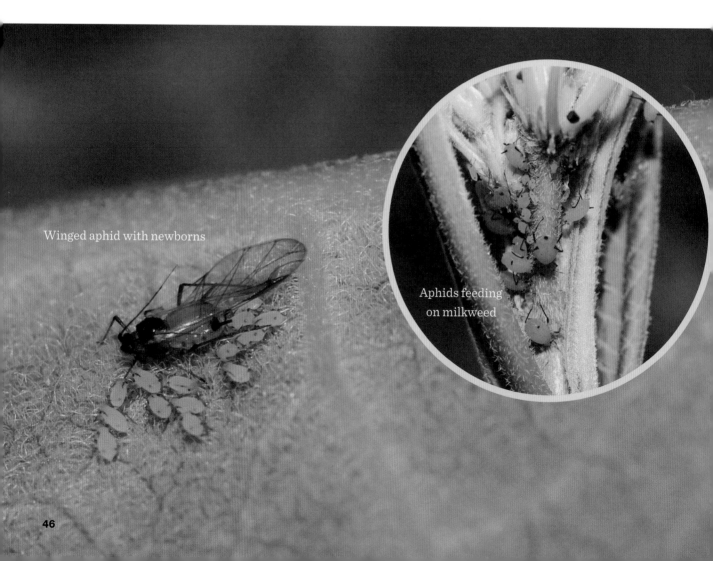

Winged aphid with newborns

Aphids feeding on milkweed

SPITTLEBUG
OTHER NAME: FROGHOPPER

Order: Hemiptera

Spittlebug nymphs have an unusual method of protecting themselves while they're feeding: They excrete a liquid from their rear end that they work into a bubbly froth that looks a lot like spit. They hide inside the foamy stuff so predators can't see them. For years we couldn't figure out who was randomly spitting on our plants; now we know!

Spittlebug adults do not produce spit, but they *are* known for being able to jump more than 100 times their own body length.

NYMPH

▼ Spittlebug nymph hiding in its "spit." The froth also helps insulate the spittlebug against excessive heat or cold.

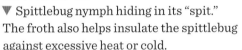

◀ Underneath the froth, the nymph can feed without being disturbed.

ADULT

The adult Spittlebug is called a Froghopper because its face resembles that of a frog.

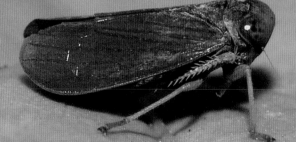

STINK BUG
OTHER NAME: SHIELD BUG

Order: Hemiptera

As you can guess from the name, Stink Bugs — one of the "true bugs" — can smell bad. Actually, they ooze, from glands on their body, a foul-smelling liquid containing cyanide compounds. They resort to this mode of self-defense only when they feel threatened, so we try not to annoy them.

EGGS

▶ The barrel-shaped eggs of the Stink Bug can be white, green, yellow, or even shiny metallic colors, depending on the species. Laid in neat rows on plant leaves, they hatch in a few days. Stink Bug nymphs stay close to their empty eggs after hatching, apparently because the nymphs require a certain bacterium to keep them healthy, and the female Stink Bug deposits a supply of the bacteria under her eggs.

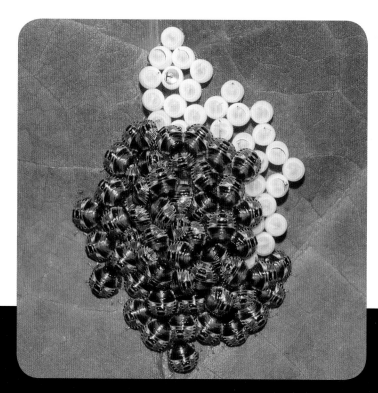

Empty Stink Bug eggs

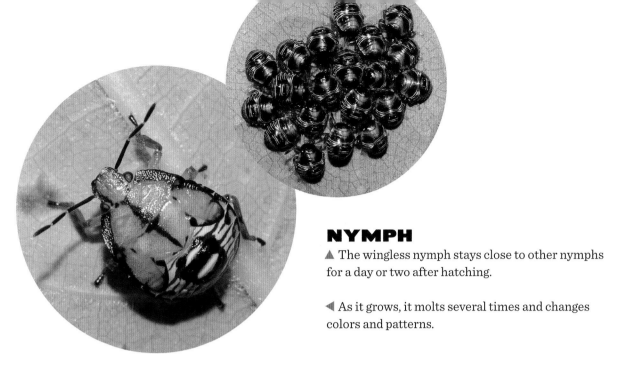

NYMPH

▲ The wingless nymph stays close to other nymphs for a day or two after hatching.

◄ As it grows, it molts several times and changes colors and patterns.

► Stink Bugs resemble beetles, but instead of chewing mouthparts, they have a piercing, tubelike mouthpart called a *rostrum*. Plant-eating Stink Bugs use the rostrum to drink plant sap and flower nectar. When the bug is not eating, it keeps its rostrum tucked beneath its body.

▲ Insect-eating Stink Bugs, like this one, use their rostrum to suck body fluids from their victims. Some farmers buy predatory Stink Bug eggs in large quantities, knowing that once they hatch, the Stink Bugs will seek out and eat caterpillars that destroy food crops.

ADULT

◄ The final molt, after about a month, reveals the mature winged adult insect. The hard covering on its back protects its wings. Adult Stink Bugs spend the winter hiding in leaf litter, waiting for spring to begin the cycle all over again.

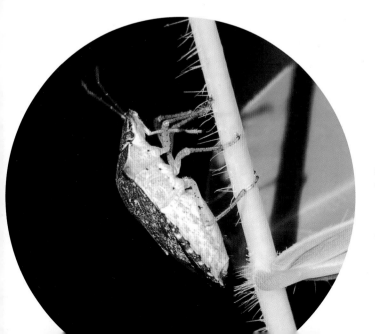

LEAFHOPPERS

Order: Hemiptera

Tiny but potentially destructive, leafhoppers insert their eggs
into plant stems. The wingless nymphs emerge and begin feeding
on the sap of the host plant, developing into mature winged adults in a few weeks.
Some are very selective about the plants they'll eat; others are not quite so picky.
Leafhoppers can overwinter as eggs or adults, depending on the species.

EGGS

▶ Leafhoppers find their mates using
courtship calls (similar to cicadas),
but their songs are too faint to be heard
by human ears. These leafhoppers are
mating.

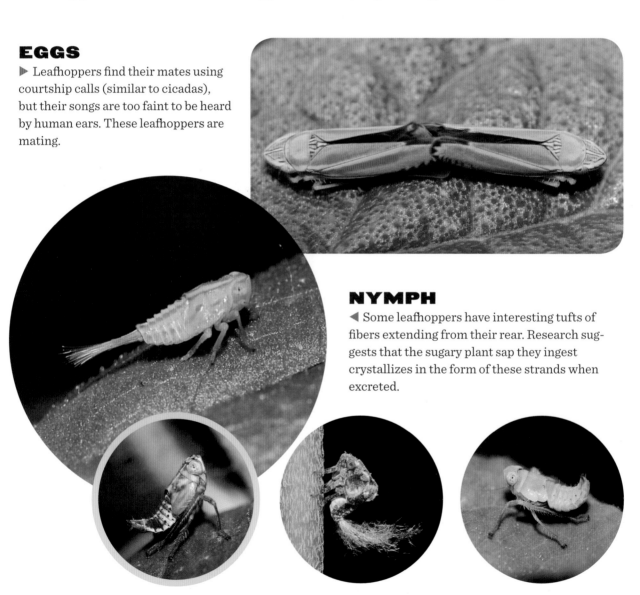

NYMPH

◀ Some leafhoppers have interesting tufts of
fibers extending from their rear. Research sug-
gests that the sugary plant sap they ingest
crystallizes in the form of these strands when
excreted.

▲ Leafhopper nymphs change color and shape as
they grow. Leafhoppers are an important food source
for birds, lizards, spiders, wasps, and other insects.

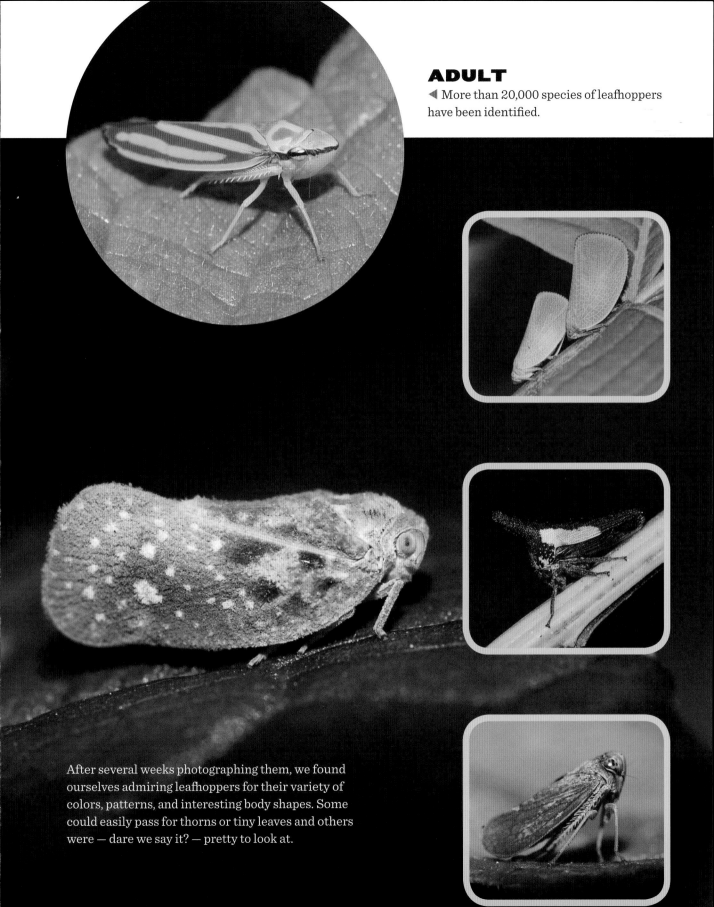

ADULT
◀ More than 20,000 species of leafhoppers have been identified.

After several weeks photographing them, we found ourselves admiring leafhoppers for their variety of colors, patterns, and interesting body shapes. Some could easily pass for thorns or tiny leaves and others were — dare we say it? — pretty to look at.

About Butterflies

Graceful, beautiful to watch, and beloved by people all over the world, butterflies also contribute to the cycle of life by pollinating flowers and allowing the development of seeds and fruits. Their plump caterpillars are an important food source for insects and some songbirds, such as the wren. They are most active during daylight hours, making them highly recognizable.

The decline in butterfly populations in recent years has caused many people to take native habitat conservation more seriously. Starting in your own backyard, you can help save wild butterflies, too. Education is the key.

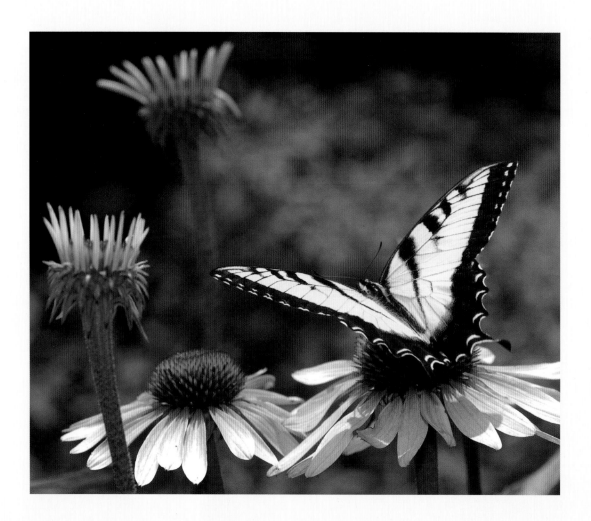

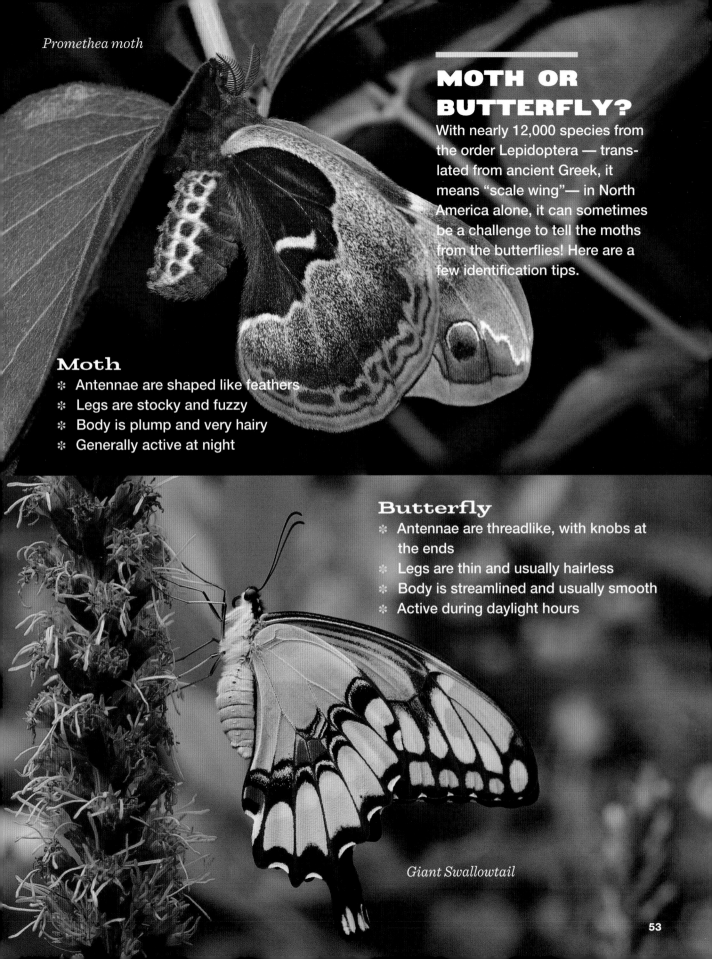

Promethea moth

MOTH OR BUTTERFLY?

With nearly 12,000 species from the order Lepidoptera — translated from ancient Greek, it means "scale wing"— in North America alone, it can sometimes be a challenge to tell the moths from the butterflies! Here are a few identification tips.

Moth

* ❊ Antennae are shaped like feathers
* ❊ Legs are stocky and fuzzy
* ❊ Body is plump and very hairy
* ❊ Generally active at night

Butterfly

* ❊ Antennae are threadlike, with knobs at the ends
* ❊ Legs are thin and usually hairless
* ❊ Body is streamlined and usually smooth
* ❊ Active during daylight hours

Giant Swallowtail

AMERICAN COPPER

Lycaena phlaeas

We first sighted this small, erratic, fast-flying butterfly while on one of our many photo adventures, and noticed that it kept visiting a small patch of weeds. Upon very close inspection — on our hands and knees, with noses almost touching the ground — we found some white dots that we hoped were eggs, and collected the leaves.

At home we had to use a magnifying glass to find out if we were right. They weren't much bigger than a period on this page, but they sure looked like eggs to us. The weed we identified as sheep sorrel, common in our area. We waited and hoped that the eggs would hatch — and sure enough, they did.

HOST PLANTS Sheep sorrel*, mountain sorrel

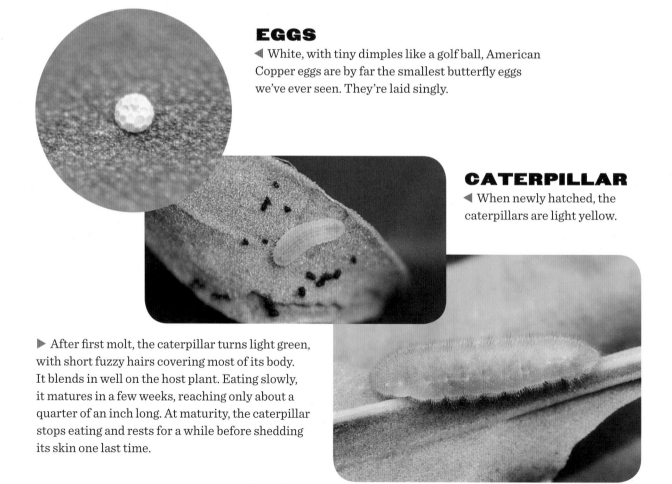

EGGS
◀ White, with tiny dimples like a golf ball, American Copper eggs are by far the smallest butterfly eggs we've ever seen. They're laid singly.

CATERPILLAR
◀ When newly hatched, the caterpillars are light yellow.

▶ After first molt, the caterpillar turns light green, with short fuzzy hairs covering most of its body. It blends in well on the host plant. Eating slowly, it matures in a few weeks, reaching only about a quarter of an inch long. At maturity, the caterpillar stops eating and rests for a while before shedding its skin one last time.

CHRYSALIS

▲ The Copper's small, bean-shaped chrysalis is green at first.

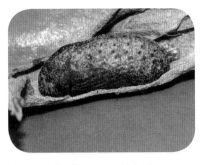

▲ It gradually turns light brown.

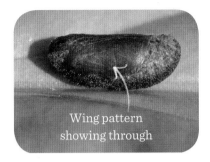

Wing pattern showing through

▲ After about ten days, the chrysalis becomes transparent.

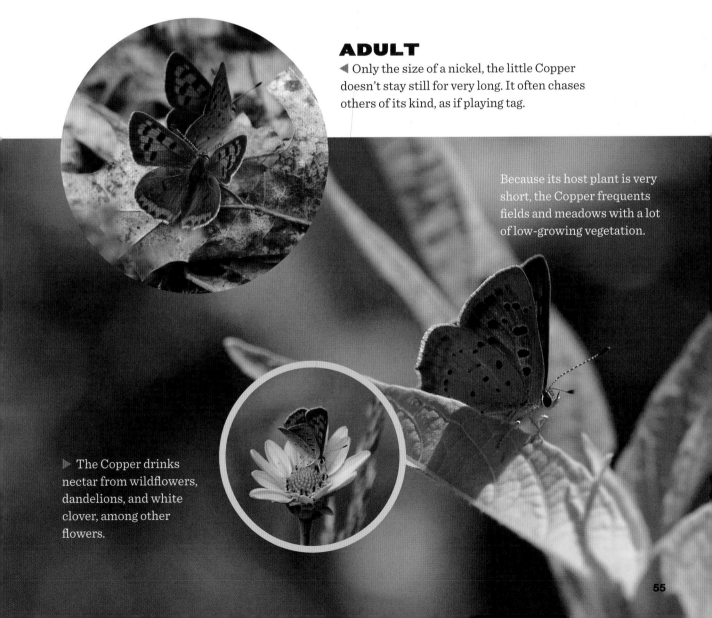

ADULT

◀ Only the size of a nickel, the little Copper doesn't stay still for very long. It often chases others of its kind, as if playing tag.

Because its host plant is very short, the Copper frequents fields and meadows with a lot of low-growing vegetation.

▶ The Copper drinks nectar from wildflowers, dandelions, and white clover, among other flowers.

AMERICAN SNOUT
OTHER NAME: COMMON SNOUT

Libytheana carinenta

This small, fast flier doesn't look like any other butterfly in this country and truly deserves its name. The Snout's "nose" really isn't a nose at all, but rather two long labial *palps* (appendages used to clean its tongue) extending along about a third the length of its body. From a distance, its colors are plain and unimpressive shades of brown, but if you take a closer look, you'll discover its true beauty.

To attract Snouts, we planted a three-foot-tall sugarberry tree, a smaller, slower-growing tree than a regular hackberry. After waiting and watching for two years, we finally saw our first female come to lay her eggs.

HOST PLANT Sugarberry (also called hackberry) tree

EGGS

▶ The Snout's very small, greenish ridged eggs are hard to see with the naked eye unless you watch them being laid. They're deposited mainly where the host tree's tender new leaves and stems branch out.

Egg

CATERPILLAR

When first hatched, the Snout caterpillar looks like a tiny worm. In early *instars* (growth stages between molts), it has a smooth, dark yellow body.

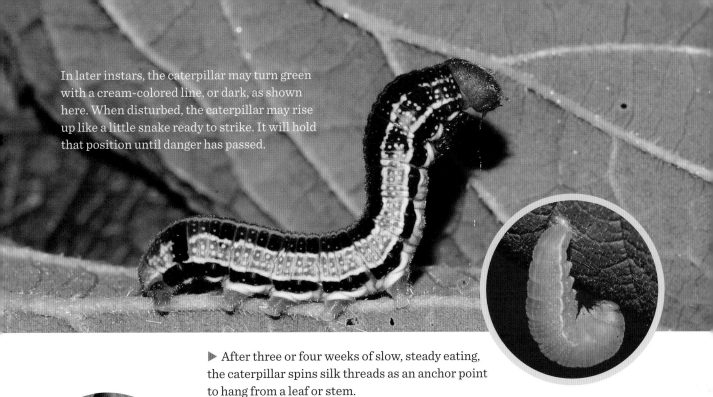

In later instars, the caterpillar may turn green with a cream-colored line, or dark, as shown here. When disturbed, the caterpillar may rise up like a little snake ready to strike. It will hold that position until danger has passed.

▶ After three or four weeks of slow, steady eating, the caterpillar spins silk threads as an anchor point to hang from a leaf or stem.

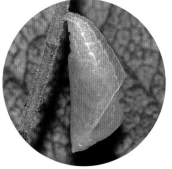

CHRYSALIS

▲ Lime green and about half an inch long, the chrysalis hangs for a few weeks.

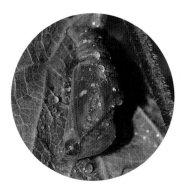

▲ Just before the butter-fly emerges, the chrysalis turns clear.

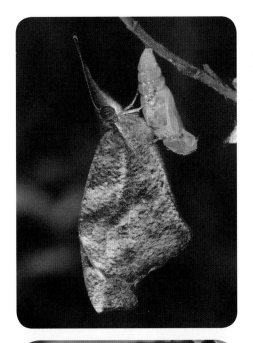

ADULT

◀ Just emerged from its chrysalis, a Snout dries its wings. The Snout often hangs upside down from a branch, almost invisible because its brown mottled wings, when closed, look like a dead leaf.

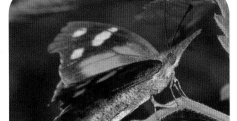

◀ Equally attracted to flower nectar and mushy fruit, the Snout doesn't linger long in one place, and is often jumpy when approached.

BALTIMORE CHECKERSPOT

Euphydryas phaeton

This lovely butterfly is becoming more difficult to find as its habitat falls victim to urban development. Isolated colonies of Baltimore Checkerspots still live in wetland meadows and around stream banks, but deer eat their favorite host plant, the white turtlehead (*Chelone glabra*), along with all the eggs and caterpillars on a plant. Whenever the deer population increases, the Checkerspot population declines.

We're trying to create a colony of Baltimore Checkerspots in our neighborhood. We hand-raise them from eggs we find in the wild, then put the newly emerged butterflies on the turtlehead plants we're growing in our own wetland garden. Butterflies taste with their feet, so they recognize their host plant when they land on it. We hope that when the females are ready to lay eggs, they'll remember to return to our garden.

HOST PLANTS White turtlehead, plantain, penstemon

EGGS

▼ In late summer, the Checkerspot lays its yellow eggs in large clusters on the underside of white turtlehead leaves. The eggs turn reddish brown as they age. Unlike most other butterfly eggs, Checkerspot eggs take a long time to hatch: about two to three weeks.

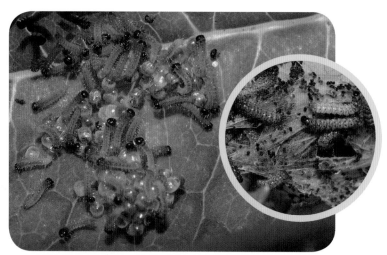

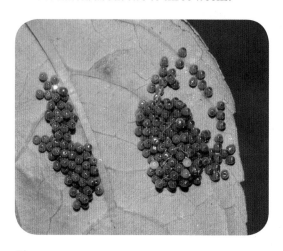

CATERPILLAR

▲ The newborn caterpillars are tiny and stay together, eating in a group. They will spin a protective silk web and eat there for up to three months.

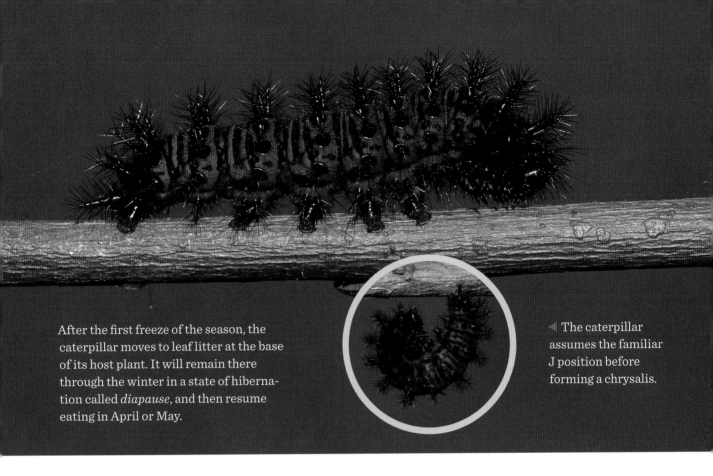

After the first freeze of the season, the caterpillar moves to leaf litter at the base of its host plant. It will remain there through the winter in a state of hibernation called *diapause*, and then resume eating in April or May.

◀ The caterpillar assumes the familiar J position before forming a chrysalis.

CHRYSALIS

▼ The striking Checkerspot chrysalis is more colorful than are most other chrysalises: its white, black, and bright orange markings don't blend into its surroundings. It may twitch from side to side if disturbed. Notice the black-and-white-striped antennae and developing wings, visible along the outside.

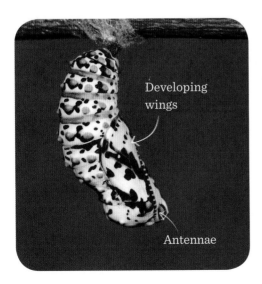

Developing wings

Antennae

ADULT

▼ After two or three weeks in the chrysalis, the butterfly emerges. Slow to eat and grow, the Checkerspot has only one brood, or generation, each year.

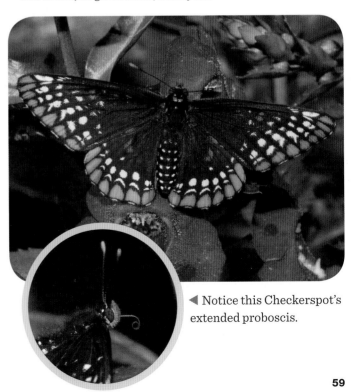

◀ Notice this Checkerspot's extended proboscis.

CLOUDLESS SULPHUR

Phoebis sennae

All yellow butterflies are not the same: the Cloudless Sulphur taught us that. There are many types of Sulphurs in this country, and it can be difficult to identify them as they fly quickly past. In our area the Cloudless, one of the largest Sulphur butterflies, migrates up from the southern states in the early summer months.

Our first sighting occurred in a large wild field of weeds where senna (*Cassia* spp.) was growing. We knew by these butterflies' much larger size that they were not the more common Clouded Sulphur , and we were happily surprised when we saw they were laying eggs on the senna's leaves and blossoms. We collected some of the eggs, bought some senna plants at our local nursery, and had a whole new life cycle to document.

HOST PLANTS Senna (*Cassia* spp.), plants in the pea family

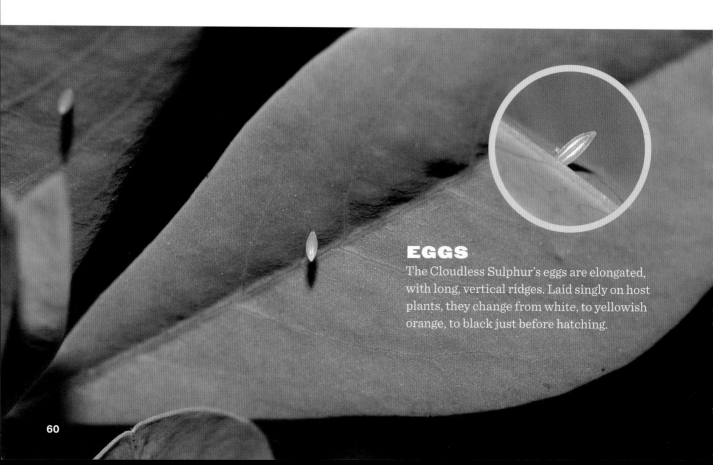

EGGS

The Cloudless Sulphur's eggs are elongated, with long, vertical ridges. Laid singly on host plants, they change from white, to yellowish orange, to black just before hatching.

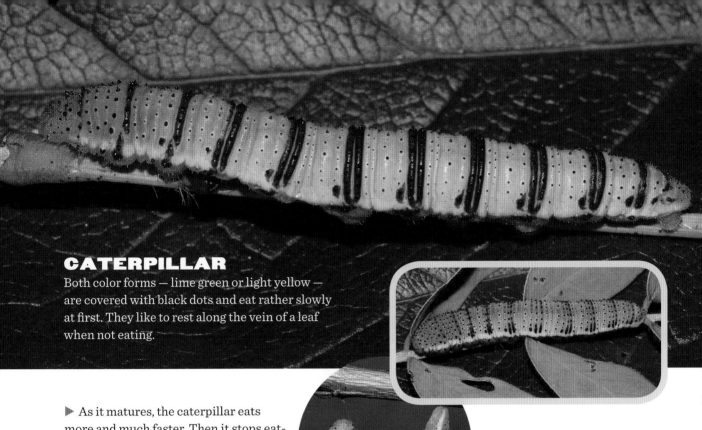

CATERPILLAR

Both color forms — lime green or light yellow —
are covered with black dots and eat rather slowly
at first. They like to rest along the vein of a leaf
when not eating.

▶ As it matures, the caterpillar eats
more and much faster. Then it stops eat-
ing altogether and secretes silk strands
to create a "harness" on a leaf or stem
that supports it as it sheds its last skin.

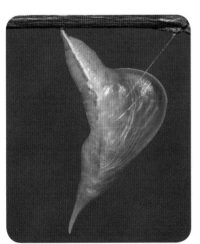

CHRYSALIS

◀ The Cloudless Sul-
phur's chrysalis is
very unusual-looking:
it resembles a little
swordfish.

◀ After a few weeks, it
turns from green to
clear, just before the
butterfly emerges.

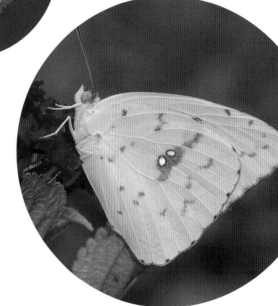

ADULT

▲ These butterflies can be seen most
often flying in open, sunny fields. The
male is lemon yellow with no markings
on the top side of its wings (see top of
facing page); the female may be yellow
or white with black wing edges.

EASTERN BLACK SWALLOWTAIL

Papilio polyxenes

Anyone who has ever grown an herb garden is probably familiar with Black Swallowtails. They're commonly found flying around gardens, farms, and overgrown fields, and their plump green-and-black-striped caterpillars like to munch on parsley plants.

HOST PLANTS Carrot, dill, fennel, parsley, Queen Anne's lace*

EGGS
◀ Laid on the leaves, stems, and flowers of their host plants, the Black Swallowtail's eggs are round.

◀ Older eggs develop a brown ring.

CATERPILLAR
The immature caterpillar is black with a white patch, called a "saddle," on its back.

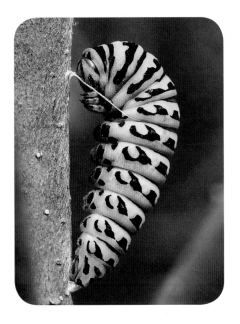

◀ As it grows and sheds its skin, the caterpillar's coloration changes to bright green with black stripes and yellow dots. When mature, it securely attaches itself to a stick or plant stem with silk threads from its spinneret and sheds its skin one last time.

▶ The last molt of the caterpillar's skin reveals the chrysalis.

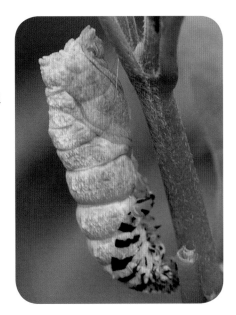

CHRYSALIS

▶ Either green or brown, the chrysalis hangs from a stick or plant stem. In warm weather, the butterfly emerges within two weeks; in cold weather, the chrysalis remains in hibernation until the following spring.

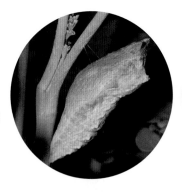

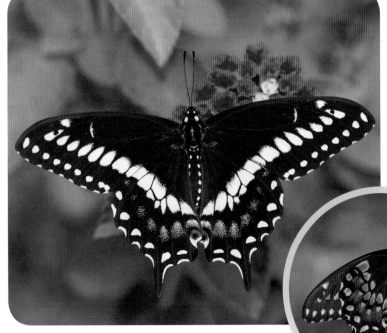

ADULT

◀ The male has a row of large, light-colored spots at mid-wing. The female (top of facing page) has much smaller spots across her wings and blue scales on each lower wing.

◀ The Black Swallowtail sometimes fans its wings as it feeds.

HACKBERRY EMPEROR

Asterocampa celtis

This quick-flying, plain-looking butterfly is the one most likely to land on you during the summer. You might think, "Wow! Am I just lucky, or does it like me?" Sorry, wrong on both counts — the Hackberry just loves the salt in your sweat, and if you're not around, fresh animal droppings will do just as nicely.

Instead of drinking flower nectar, this little butterfly prefers to get salts from sweat, protein from animal droppings, sugars from rotten fruit, and minerals from decaying flesh. The Hackberry can be found around woodland edges, near creeks, and in other damp areas. Its flight is fast and erratic, and it often rests upside down on tree trunks, which can make it difficult to spot.

HOST PLANTS Hackberry tree, sugarberry tree

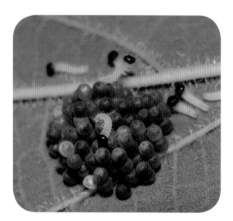

EGGS

▲ Newly laid Hackberry eggs are whitish with small ridges. They're laid in clusters of sometimes 100 eggs on hackberry tree leaves. The eggs darken before they hatch.

CATERPILLAR

◀ At first the caterpillars are light yellow with a solid black head. They like to eat in groups, often working from the outside of a leaf toward the middle vein.

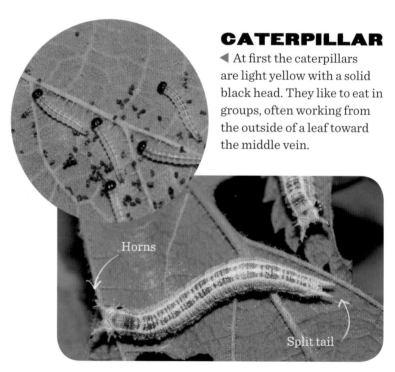

Horns

Split tail

▲ As the caterpillar grows, its color changes to light green with a yellow ladder design along its back. It develops two green or black horns that resemble antlers, and a pronounced split rear end.

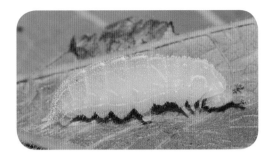

▲ After about three weeks, the caterpillar attaches itself to a leaf to molt one last time.

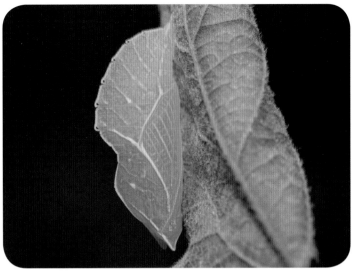

CHRYSALIS

▲ The light green, ridged chrysalis is attached to a leaf rather than a branch or stem, as other butterfly chrysalises are. It looks so much like a leaf that it is almost invisible positioned against a green one.

ADULT

◀ After a few weeks, the butterfly emerges.

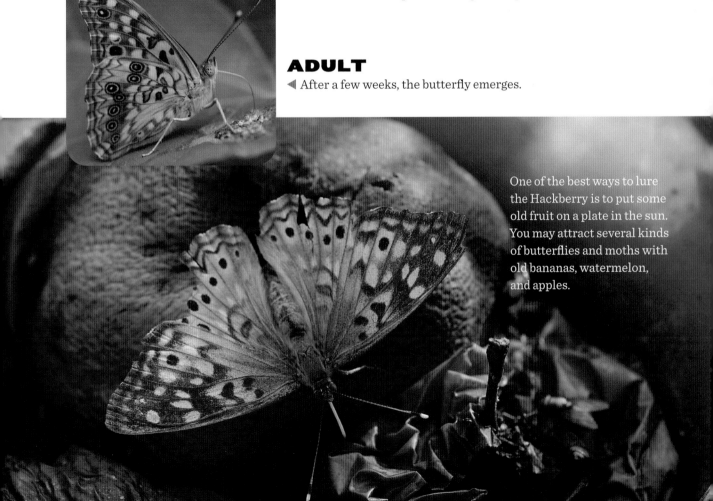

One of the best ways to lure the Hackberry is to put some old fruit on a plate in the sun. You may attract several kinds of butterflies and moths with old bananas, watermelon, and apples.

MONARCH

Danaus plexippus

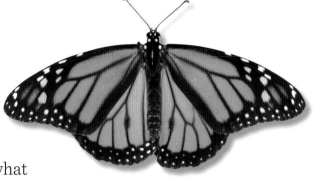

The Monarch, the most familiar North American butterfly, also has the best press agent: we'd bet that anyone over five knows what a Monarch butterfly looks like. They can be found in much of the central and southern parts of the continent, and we've raised hundreds of them over the years. They're easy to attract by growing their host plants, which comprise all types of milkweed.

Every fall Monarchs make an amazing journey, flying from as far away as Canada to their overwintering grounds in Mexico. During migration, they travel in such large groups that the branches of the trees they roost in sag beneath their weight. In the spring, the pregnant females start the long journey back from Mexico to the United States and Canada to begin their life cycle all over again.

HOST PLANT Milkweed

EGGS

▼ The Monarch female lays her eggs on milkweed leaves.

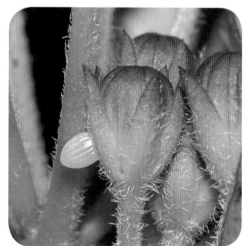

▲ Cream-colored at first, the eggs turn darker after a few days.

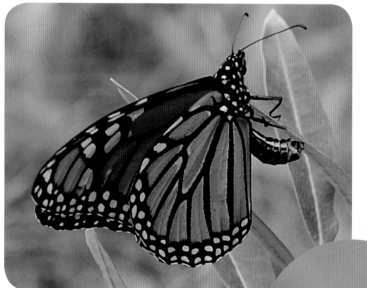

◀ The caterpillar's head becomes visible just before it eats its way out of its egg.

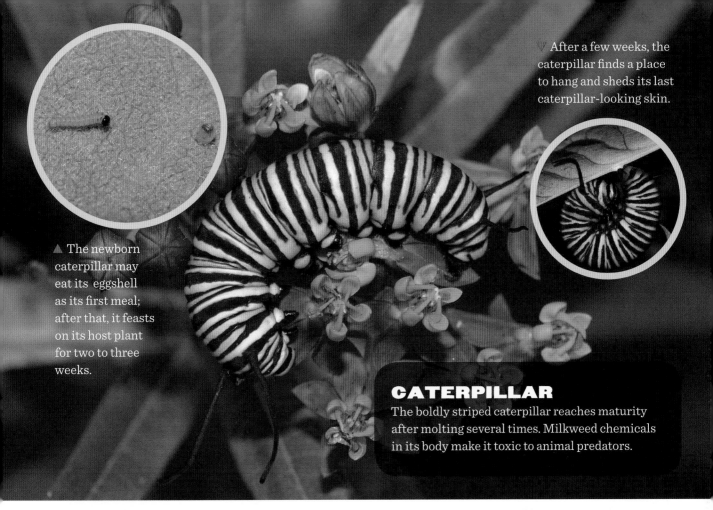

After a few weeks, the caterpillar finds a place to hang and sheds its last caterpillar-looking skin.

▲ The newborn caterpillar may eat its eggshell as its first meal; after that, it feasts on its host plant for two to three weeks.

CATERPILLAR

The boldly striped caterpillar reaches maturity after molting several times. Milkweed chemicals in its body make it toxic to animal predators.

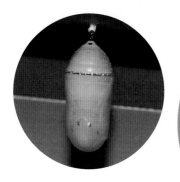

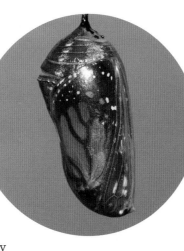

ADULT

▼ The newly emerged butterfly rests for about an hour to allow its wings to expand, dry, and harden before taking its first flight.

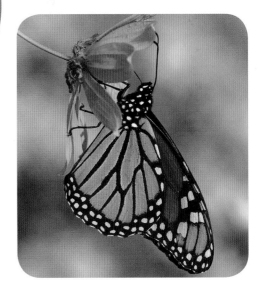

CHRYSALIS

▲ The Monarch's beautiful green and gold chrysalis may be found hanging in some very interesting places, such as on a garden statue or a swimming pool edge. It becomes transparent after about ten days.

MOURNING CLOAK

Nymphalis antiopa

For years, in spite of the variety of flowers we had, we couldn't manage to attract Mourning Cloaks to our yards. Then one day we set out a feeder full of overripe fruit, and understood our mistake: These large, elusive butterflies don't rely on flower nectar for food. Instead, they'll sip tree sap, juices from rotten fruit and berries, and liquids from animal droppings. Mushy bananas seem to be their favorite treat.

Now that we know how to attract them, Mourning Cloaks often venture out from their habitat in the woods to eat or to sun themselves on the rocks in our gardens.

HOST PLANTS Trees in the willow family; also poplar, elm, hackberry, and birch trees

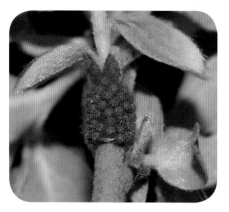

EGGS

◀ Mourning Cloak females lay their golden brown eggs in large masses. They have ridges running along them from top to bottom.

▶ The tiny eggs turn darker bluish black in a few days.

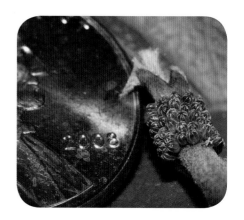

CATERPILLAR

▶ The caterpillars are dark yellow when newborn.

◀ They eat in a group, becoming browner as they get older. They spin silk webs around a portion of the host plant, creating a tent in which to hide while eating.

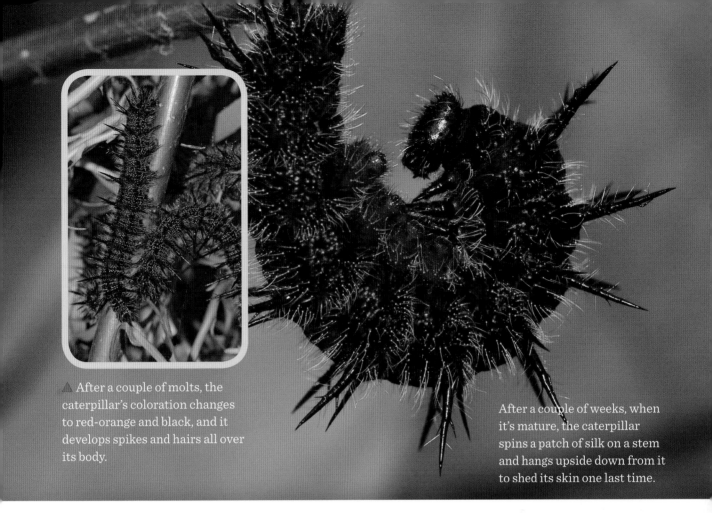

After a couple of molts, the caterpillar's coloration changes to red-orange and black, and it develops spikes and hairs all over its body.

After a couple of weeks, when it's mature, the caterpillar spins a patch of silk on a stem and hangs upside down from it to shed its skin one last time.

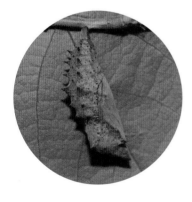

CHRYSALIS

▲ The grayish brown chrysalis has spikes that look like they've been hand-painted red at the tips. It will twitch and jerk away if touched. Its earth-tone colors and sudden movements serve as defense mechanisms.

ADULT

▶ The adult Mourning Cloak emerges in about two weeks. The adult overwinters and is usually the first butterfly we see in the spring. A fast, strong flier, the Mourning Cloak frequents woodlands and gardens. When disturbed, it will often zip a short distance away and then return to the same spot. Mourning Cloaks may *estivate* (go dormant) during the hottest part of summer, feed again in the fall, and overwinter under loose tree bark or in some other protected area.

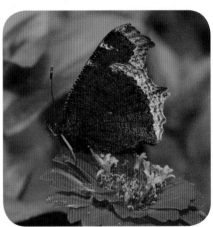

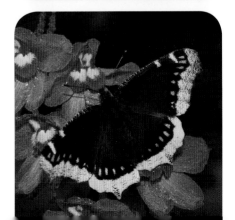

SILVER-SPOTTED SKIPPER

Epargyreus clarus

This small, rather dull-looking butterfly is often overlooked. Rather than posing on flowers, it likes to dart back and forth and is sometimes mistaken for a moth.

We were sitting on our deck one day when we noticed a little butterfly that kept landing on our wisteria vine. After watching for about half an hour, we looked closely at the vine's leaves. Sure enough, we had eggs. Not only were they surprisingly pretty, but they were also surprisingly large, especially for such a small butterfly. Silver-spotted Skippers' eggs are as big as Swallowtail eggs, although the adult Skipper is half the Swallowtail's size.

HOST PLANTS Wisteria, black locust, false indigo, legumes, rose acacia, and senna (*Cassia* spp.)

EGGS

▶ Skipper eggs are laid singly, usually on the top of the host plant's leaves. When newly laid, they're light green with tiny ridges. After about three days, they turn white with a beautiful pink swirl before becoming transparent, the caterpillar showing from inside.

CATERPILLAR

▼ When it's not eating, the newly hatched caterpillar likes to hide in a folded piece of leaf held together with silk. In early instars, it has a solid black head with a greenish yellow body.

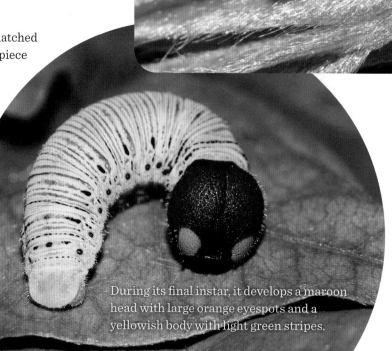

During its final instar, it develops a maroon head with large orange eyespots and a yellowish body with light green stripes.

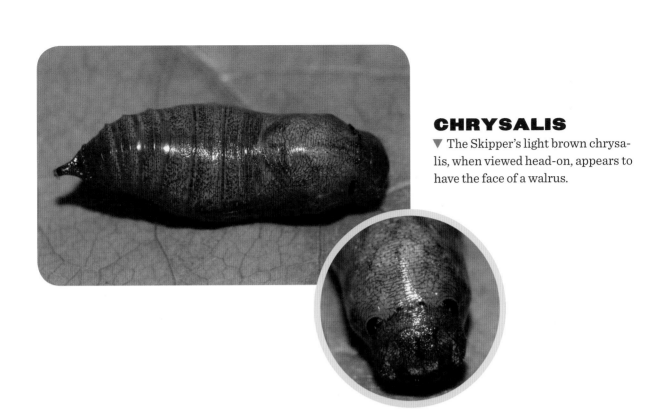

CHRYSALIS

▼ The Skipper's light brown chrysalis, when viewed head-on, appears to have the face of a walrus.

ADULT

After about two weeks, the adult Skipper emerges to search for a mate. It flies in quick bursts, "skipping" from one plant to another, mostly in open fields and gardens. It hangs upside down under leaves to rest. It often seems to be curious, flying at people and other insects.

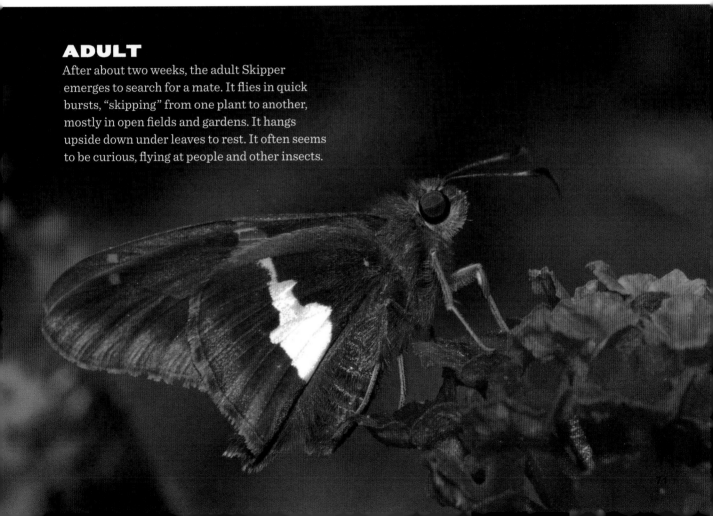

SPRING AZURE

Celastrina ladon

Imagine a lovely blue butterfly that's small enough to fit on a dime: that's the Spring Azure, one of the earliest and tiniest spring butterflies. We never fail to see them when we take walks in search of spring wildflowers. They are fast, erratic fliers that barely sit still long enough for a photo and almost never pose with their shiny blue wings open. The males of the species are bright, metallic blue; the females lean more toward dusty bluish gray. The undersides of the wings of both genders are whitish gray.

Like many other butterflies, the males seek out muddy areas on trails, roadsides, and stream edges to sip the dissolved salts and minerals they require for reproduction. These "puddle parties" offer a rare chance to observe these butterflies while they're preoccupied.

HOST PLANTS Flowering dogwood, New Jersey tea, gray dogwood, and viburnum

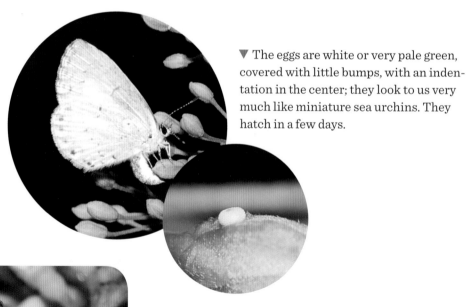

EGGS
▶ The Spring Azure usually lays her eggs singly on a host plant's flower buds.

▼ The eggs are white or very pale green, covered with little bumps, with an indentation in the center; they look to us very much like miniature sea urchins. They hatch in a few days.

CATERPILLAR
◀ The tiny yellow caterpillar starts to eat holes in the flower buds immediately after hatching. It soon turns green or a pale cream. Spring Azure caterpillars are known as slug-caterpillars because they lie flat on the plant with neither legs nor head visible.

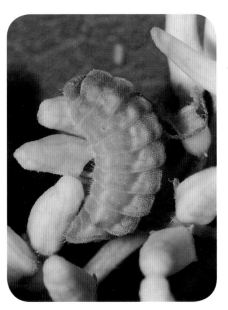

◀ The caterpillars sometimes match the color of the flowers they eat. In the wild, some secrete a sweet liquid that ants find delicious; in turn the ants may offer some protection against parasitic wasps that prey on caterpillars.

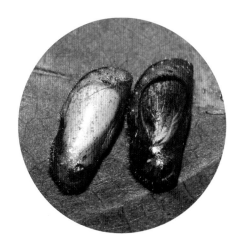

CHRYSALIS

▲ The compact chrysalis of the Spring Azure can vary somewhat in color depending on the color of the caterpillar. Light-colored at first, it gradually turns brownish and then becomes transparent before the butterfly emerges. On the right, you can see the Azure's brilliant blue wing showing through.

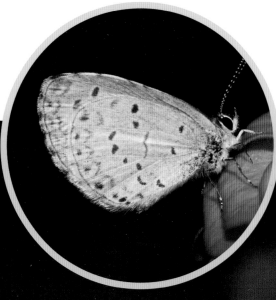

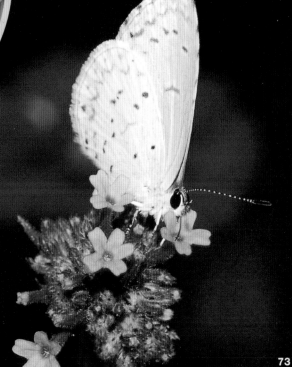

ADULT

In hot weather, the butterfly emerges in a week or so, and can be found in deciduous woods, old fields, woodland trails, marshes, parks, and damp roadsides. The male butterflies are normally the more active, patrolling for females.

TIGER SWALLOWTAIL

Papilio glaucus

During the spring and summer months, we regularly rescue Tiger Swallowtail eggs and caterpillars from our local nurseries. The nursery owners are glad to have us remove them before the caterpillars devour the leaves of their merchandise! We've adopted hundreds of different butterflies this way. (A word of caution, however: Adopt your own butterflies, and buy your own host and nectar plants, from local nurseries that don't spray their plants with insecticides.)

We like to keep the host trees in our yards pruned to six or seven feet tall so we can observe or collect the eggs and caterpillars. After we hand-raise the butterflies, we set them free in our gardens and they return later to eat, look for mates, and lay their eggs.

HOST PLANTS Tulip poplar, wild black cherry, sweet bay magnolia, and ash trees

EGGS
▲ Round, green, and laid one per leaf, the eggs hatch after a few days.

CATERPILLAR
▶ The tiny caterpillar's first meal may be its empty eggshell. To trick predators, its brown and white markings give it the appearance of bird droppings.

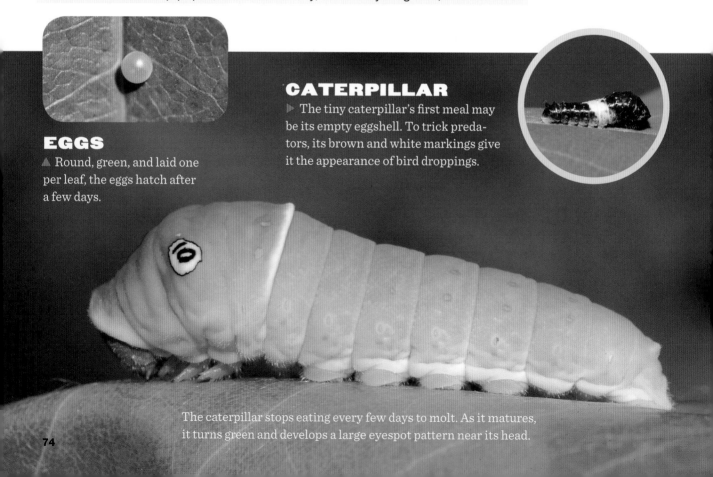

The caterpillar stops eating every few days to molt. As it matures, it turns green and develops a large eyespot pattern near its head.

CHRYSALIS

▶ The mature caterpillar spins a silk harness around itself and hangs from a tree limb before shedding its last skin. The chrysalis's earth-tone colors blend in with tree bark and provide camouflage. If formed late in the season, the chrysalis will hibernate until warmer weather arrives in the spring.

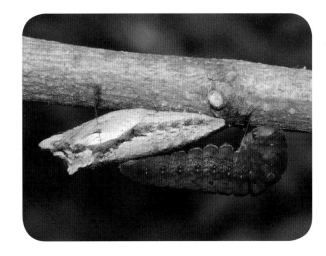

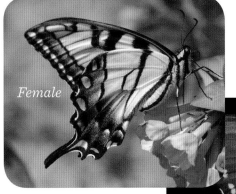

Female

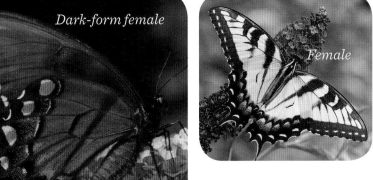

Dark-form female

Female

ADULT

▲ If the chrysalis is formed in summer, the butterfly will emerge in less than two weeks.

▶ The female sometimes exhibits a dark form, more common in Georgia and Florida.

▲ In both sexes, a long, thin, black "tail" extends from each lower wing. A male is shown at top of facing page.

HIDE AND SEEK

When the Tiger Swallowtail caterpillar spins silk threads around a leaf, the silk shrinks as it dries, curling the leaf up around the caterpillar and hiding it from the view of birds. This doesn't fool all the birds, though: During nesting season we've seen wrens bite right through the middle of curled leaves, looking for fat caterpillars to feed their babies.

WILD INDIGO DUSKYWING

Erynnis baptisiae

Members of the Skipper family, Duskywings have several physical characteristics that set them apart from other butterflies. They have small wings, a fat body, and antennae with curved tips. These traits, along with their small size and drab colors, give the Duskywings a mothlike appearance.

Duskywings can be found in open fields and wildflower meadows. We enjoy watching their quick, erratic flight in our gardens, too, where they spend a lot of time drinking nectar from our purple coneflowers. They're so fast and unpredictable with their antics that sometimes we think they can even fly backwards.

HOST PLANTS Wild indigo, blue false indigo, lupine, crown vetch*

EGGS
◀ The Duskywing lays her eggs singly on several different host plants. The ridged eggs are white initially but turn orange as they age. They hatch within a few days.

CATERPILLAR
▲ Yellowish green at first, the Duskywing caterpillar hides from predators by chewing a small section of leaf, folding it over, and securing it with silk to make a little tent.

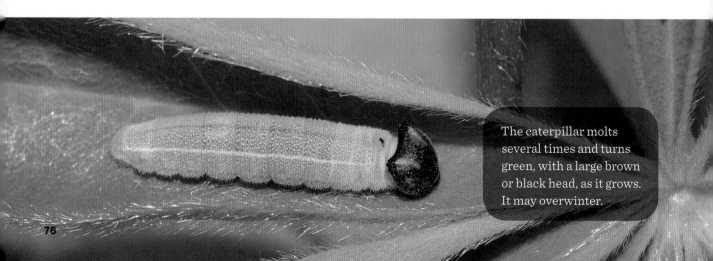

The caterpillar molts several times and turns green, with a large brown or black head, as it grows. It may overwinter.

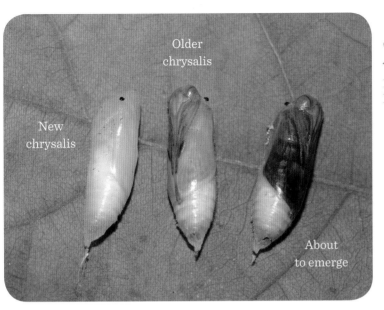

New chrysalis

Older chrysalis

About to emerge

CHRYSALIS

◀ The green chrysalis becomes transparent just before the butterfly emerges. In some cases, the chrysalis may hibernate until spring.

ADULT

▶ These Duskywings are mating. Duskywings have two broods per year.

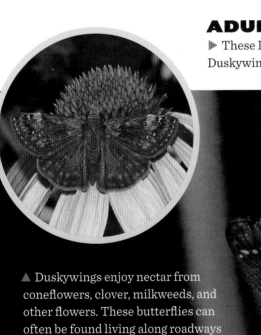

▲ Duskywings enjoy nectar from coneflowers, clover, milkweeds, and other flowers. These butterflies can often be found living along roadways and railroad-track embankments where crown vetch*, one of their host plants, is widely planted to control soil erosion.

About Moths

Even though moths outnumber butterflies many times over, they seldom get as much attention as do their more colorful cousins. Most moths do their flying at night, so people rarely have a chance to see their beauty. Because some moth larvae infest stored food, nibble on household woolens, or demolish important crops, it's easy to think of them as a nuisance. But adult moths play a vital role in feeding birds, bats, and many species of insects, and they also pollinate flowers — think of that the next time you're tempted to reach for the swatter!

We've raised many moths from egg to pupa to egg-laying adult, photographing the changes we observed along the way. If you decide to try this yourself, be careful when handling any caterpillar: some are capable of giving you a nasty sting. Adult moths are generally harmless, however — and some have no mouth at all.

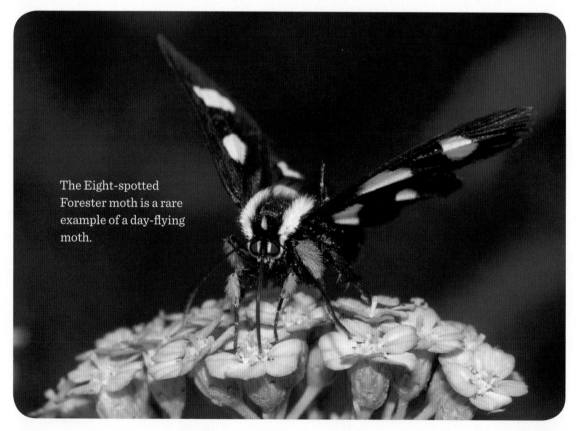

The Eight-spotted Forester moth is a rare example of a day-flying moth.

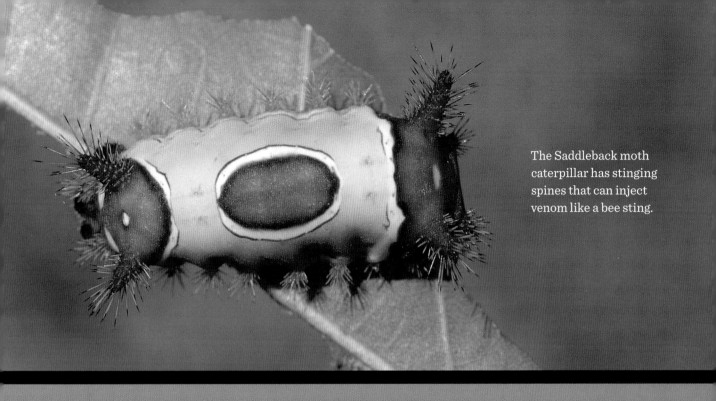

The Saddleback moth caterpillar has stinging spines that can inject venom like a bee sting.

HUNGRY CATERPILLARS

The Forest Tent moth is probably best known for its caterpillars, which hatch in silky "tents" in deciduous trees and systematically strip the leaves from the branches.

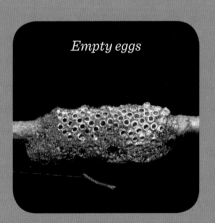

Empty eggs

Caterpillars

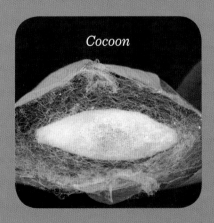

Cocoon

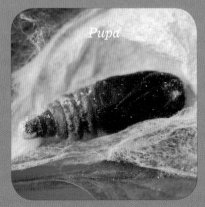

Pupa

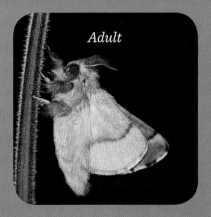

Adult

CECROPIA MOTH

Hyalophora cecropia

This gorgeous creature, the largest moth in North America, has a wingspan equal to that of a small bird. Startled to find a mating pair of these moths while out for her morning walk, a friend of ours carefully broke off the small tree branch they were clinging to and gave them to us. This was our first encounter with Cecropias, and we could hardly believe how big they were!

After the pair separated, that evening we released the male in the woods. The female laid more than 100 eggs during the next couple of days and died shortly thereafter. Giant silk moths such as the Cecropia live for just a week or two and fly only at night, so most people have never seen one. You're more likely to see the Cecropias' large, colorful caterpillars chewing on their host trees' leaves.

HOST PLANTS Sweetgum, pear, apple, willow, and cherry trees

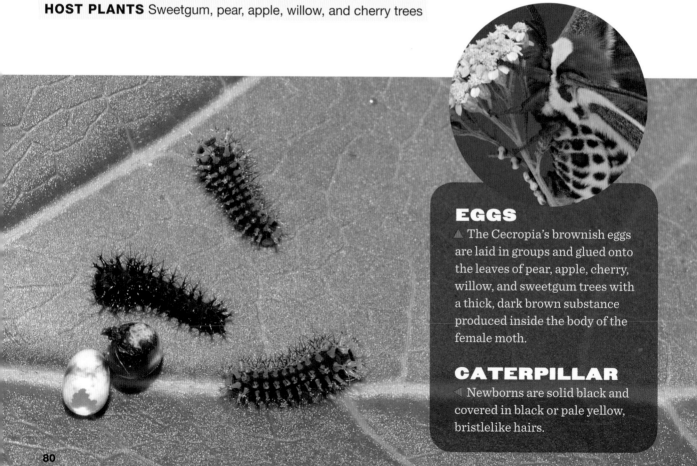

EGGS

▲ The Cecropia's brownish eggs are laid in groups and glued onto the leaves of pear, apple, cherry, willow, and sweetgum trees with a thick, dark brown substance produced inside the body of the female moth.

CATERPILLAR

◀ Newborns are solid black and covered in black or pale yellow, bristlelike hairs.

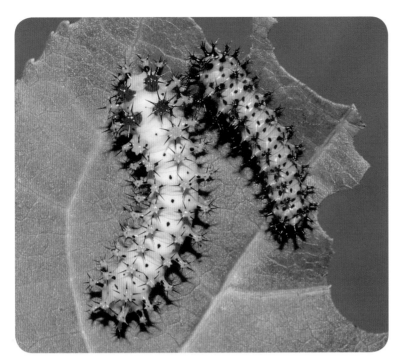

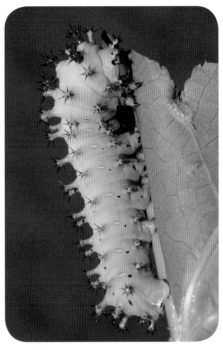

▲ The caterpillars shed their skin five times over a period of six to ten weeks as they eat and grow, changing color every time. They are active day and night.

▲ When mature, the caterpillar is covered in red, yellow, and blue spiked knobs. It spins a silk cocoon and molts inside it one last time.

PUPA

▼ The brown pupa spends the cold months hibernating.

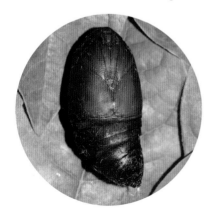

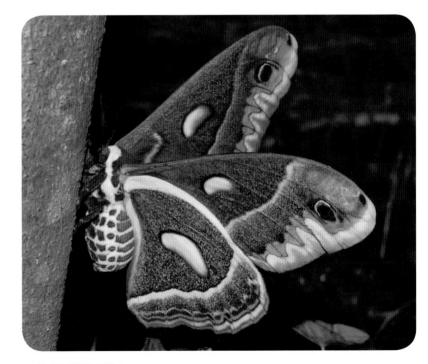

ADULT

▲ Giant silk moths do not have a mouth or tongue, so they do not eat.

IMPERIAL MOTH

Eacles imperialis

These big (average wingspan is 4 to 5 inches) yellow night-fliers belong to a family of large, pretty moths called the Saturniids. They have just one brood each year. Their natural habitat is usually forests, where their host trees are found, but you might see one some hot summer night perched on the side of your house near a floodlight.

HOST PLANTS Sweetgum, walnut, hickory, oak trees

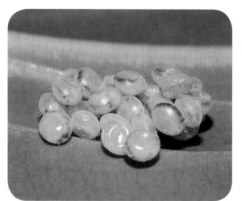

EGGS
◀ The Imperial lays its yellow eggs in groups. The eggs become transparent just before the caterpillars chew their way out.

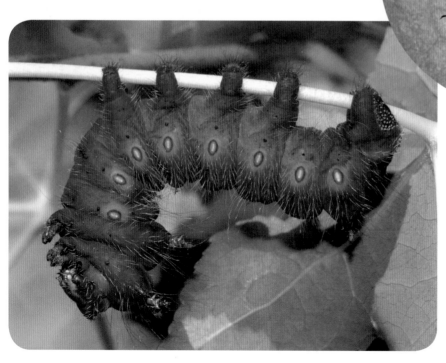

CATERPILLAR
▲ The caterpillars hatch within two weeks and wander around for a while before settling down to eat.

◀ Although these caterpillars can be green, those in our yard appeared in shades of brown ranging from orangish to almost black.

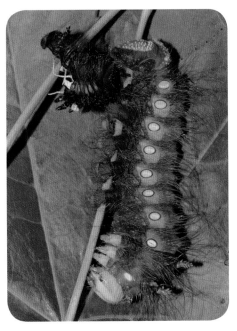

◀ The caterpillar molts by spinning some silk on a leaf vein or stem, grabbing it with its anal claspers, and wiggling out of its old skin, taking in extra air to stretch out and dry the new, moist skin and create room for growth. It sometimes eats the discarded skin.

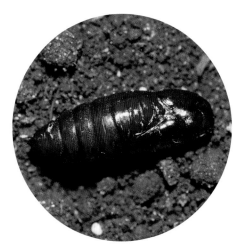

PUPA

▲ At the end of the fifth instar, the caterpillar leaves the host tree in search of soft soil to burrow into. It digs a little tunnel in the dirt and sheds its skin for the last time. The pupa rests underground through the winter.

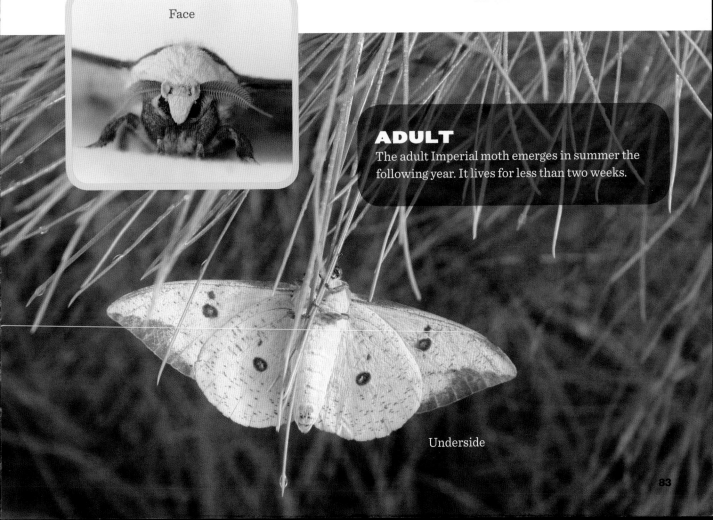

Face

ADULT

The adult Imperial moth emerges in summer the following year. It lives for less than two weeks.

Underside

IO MOTH

Automeris io

We've raised many moth species over the years, and we usually encourage other people to try it too. Not in this case! Io moth caterpillars are best left alone and observed in the wild. The hollow spikes all over their body are connected to poison sacs. If you touch one of the spikes, you might feel anything from an intense nettling sensation to severe pain, fever, and nausea.

When we raised Io moth caterpillars from eggs, we had to be extremely careful not to touch them during feeding or while taking photos. A funny thing we noticed, though: the caterpillars are very social with each other when they're eating, and they cuddle in groups to sleep.

HOST PLANTS Willow, cherry, hackberry, elm, and poplar trees; corn and clover

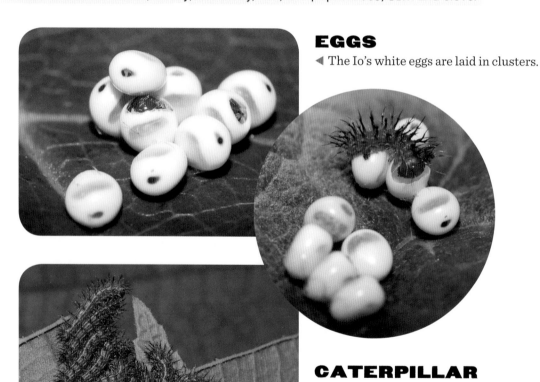

EGGS
◄ The Io's white eggs are laid in clusters.

CATERPILLAR
▲ After a few weeks, the caterpillars hatch. They are dark orange, covered with tiny black spikes.

◄ In a few weeks, they become a lighter orange. They eat and rest in groups.

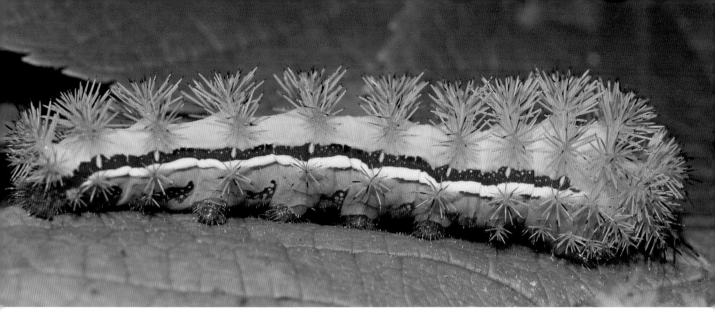

CATERPILLAR

▲ When more than half grown, the caterpillar's markings change to bright green with a red-and-white stripe along the body.

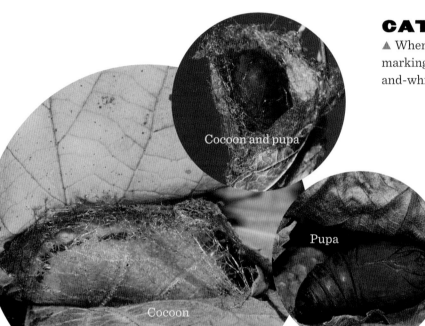

Cocoon and pupa

Cocoon

Pupa

PUPA

◀ The cocoon is made from sewn-up leaves. The pupa forms inside.

ADULT

▶ The female Io (with an average wingspan of 3 inches) is larger than the male and has more-muted coloration.

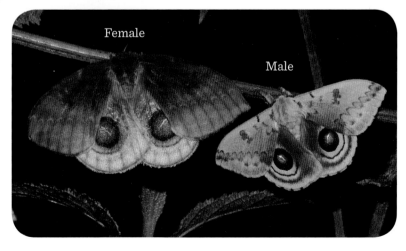

Female

Male

LUNA MOTH

Actias luna

Lunas are as beautiful as any butterfly, and are attracted to artificial light, especially ultraviolet. We once took home an injured female Luna and put her in a mesh container with a branch from a sweetgum tree. That night she laid 120 eggs all over the leaves, and we raised the moths by hand over the next few months.

When the adults emerged from their cocoons, we thought we'd done something wrong: Their wings were tiny, their bodies long and squishy. They struggled to crawl around. Then they started to climb up the sticks we'd placed in their container. Mesmerized, we watched as the wings began to grow larger and the body segments drew together and compressed like an accordion. After about 20 minutes, their wings had fully expanded (to a wingspan of 5 inches), their bodies had shrunk, and the moths rested until nightfall, when they were ready to fly.

HOST PLANTS Hickory, black walnut, sweetgum, birch, and pecan trees

EGGS

▶ Luna moths lay their eggs in groups of three to seven. They look like somewhat flattened spheres in shades of brown and cream.

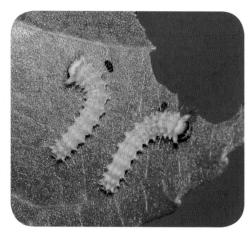

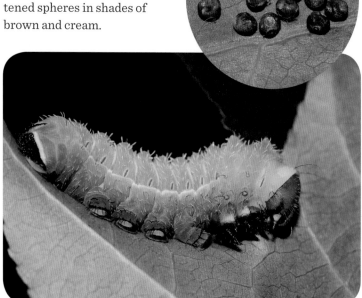

CATERPILLAR

▲ The tiny green caterpillars hatch in about ten days and immediately start eating their host tree's leaves.

◀ They'll eat voraciously for more than a month, shedding their skin five times as they grow.

PUPA

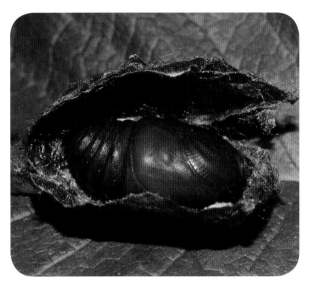

▲ The mature caterpillar spins silk around leaves to form a cocoon. When the silk dries, the cocoon turns brown and papery.

▲ Hidden inside the cocoon, the caterpillar sheds its skin one last time and exposes a brown pupa that looks like this. If the cocoon is formed in summer, the moth will emerge in about a month. If it's formed in autumn, the pupa will hibernate inside the cocoon until the following spring, when the moth emerges.

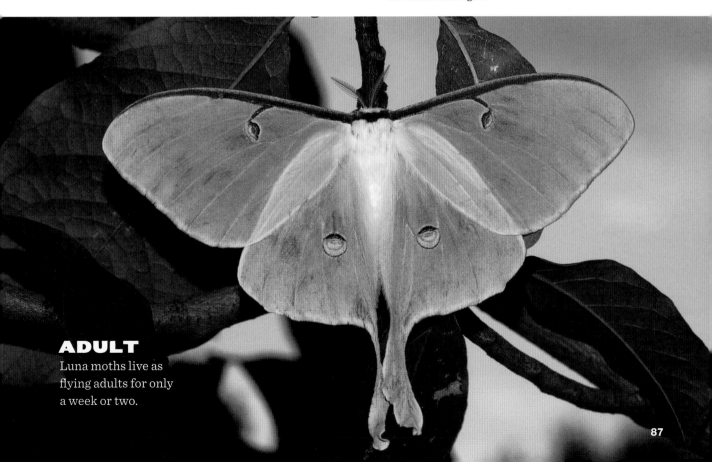

ADULT
Luna moths live as flying adults for only a week or two.

POLYPHEMUS MOTH

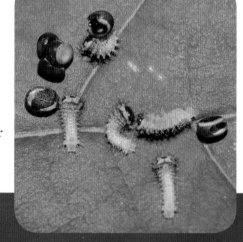

Antheraea polyphemus

Named after a mythical Greek giant who had one
huge eye in the middle of his forehead, Polyphemus moths
have a large, beautiful eyespot pattern on each lower wing. Their dominant coloring can be pink, brown, gray, or reddish cinnamon. These lovely creatures helped increase our interest in moths.

HOST PLANT Red oak, apple, ash, maple, birch, dogwood, and willow trees

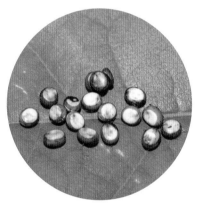

EGGS
◀ The Polyphemus moth lays its round, flattened, brown-and-cream-colored eggs in groups on a number of host trees.

CATERPILLAR
▶ The brown-faced caterpillars hatch in about a week. Over a two-month period, they will shed their skins five times.

As they grow the caterpillars develop little knobs, called *scoli*, that may be yellow, orange, or shiny silver, with tufts of hair sticking out of each one. Polyphemus caterpillars may be 3 to 4 inches long at maturity and sometimes make a snapping sound with their mandibles.

Scoli

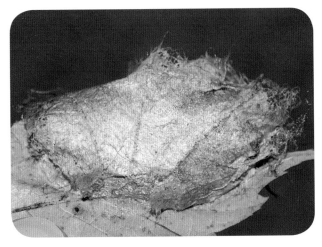

PUPA

◀ The mature caterpillar wraps itself in leaves from its host tree and spins itself a protective cocoon to pupate in. If the weather is still hot, the moth will emerge in a couple of weeks. If fall is approaching, the pupa will rest through the winter and the moth will emerge the following spring.

ADULT

▶ Males have large, feathery antennae that can detect chemical signals from females many miles away. Females are plumper than males, their bodies filled with hundreds of eggs; they usually sit and wait for the males to find them.

▼ Once out of the cocoon, the moth must cling to a branch and begin pumping body fluid, called *hemolymph,* into its small, floppy wings. Until the wings fill up, stretch out (wingspan is 4 to 5 inches), dry off, and become rigid, the moth can't fly.

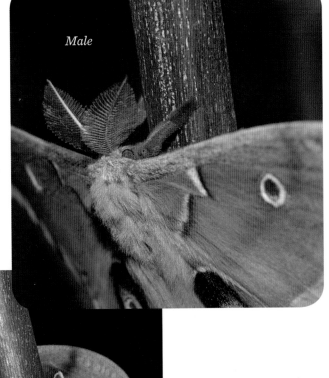

Male

Underside of male

PROMETHEA MOTH
OTHER NAME: SPICEBUSH SILK MOTH

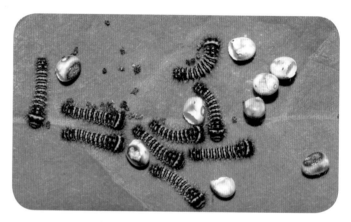

Callosamia promethea

Another member of the Giant Silk Moth family, the Promethea moth is a favorite of ours. We like their eyespots, and the lightning-bolt patterns that seem almost to glow on their wings. They are very easy to rear, and guests — especially kids — at our insect presentations really love them. We pass them around the audience so everyone can handle them and get a good close-up look.

HOST PLANTS Spicebush, sassafras, ash, cherry, magnolia, lilac, and tulip trees

EGGS
▶ The Promethea lays its light brown eggs in small groups.

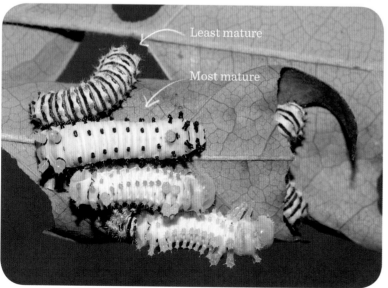

Least mature

Most mature

CATERPILLAR
◀ The caterpillars change colors with almost every molt: newborns are black-and-yellow-striped and covered in hairs; in older caterpillars, the yellow stripes become more prominent; and eventually the yellow stripes become white bands separated by black stripes.

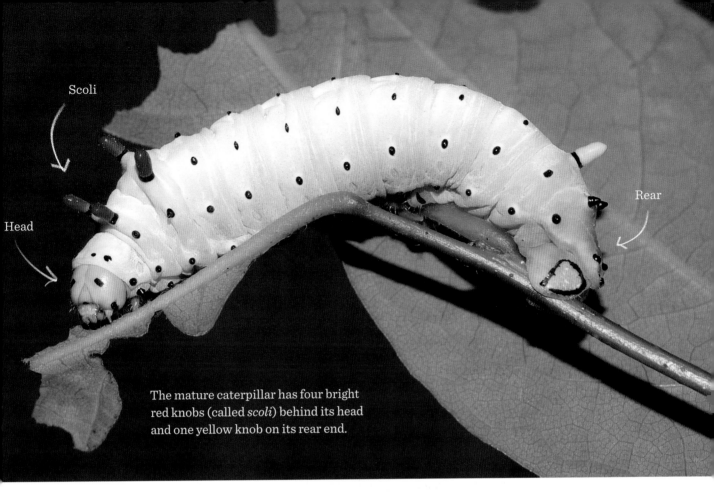

Scoli

Head

Rear

The mature caterpillar has four bright red knobs (called *scoli*) behind its head and one yellow knob on its rear end.

PUPA

▶ The mature caterpillar forms a cocoon by rolling up in a leaf and spinning brown silk around it. Anchored to a tree branch, the pupa remains in its cocoon through the winter; the moth emerges in the spring.

Cocoon

Pupa without cocoon

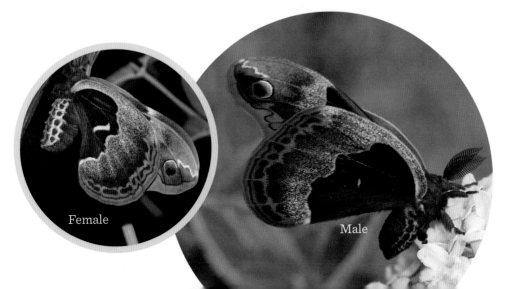

Female

Male

ADULT

◀ You might see a male Promethea in the later afternoon, but the female flies only after dark. The moth's average wingspan is 3 to 4 inches.

ROYAL WALNUT MOTH

OTHER NAME: REGAL MOTH

Citheronia regalis

This large moth, with its distinctive markings, is best known for its caterpillar form, the Hickory Horned Devil. It's the largest caterpillar in North America. While its name and appearance are scary, the caterpillar has no way to sting or bite you. If you handle one, however, you'll find that its feet have tiny hooks that can hang on very tightly. It's best to wait for it to wander off your hand.

We started raising these delightful creatures when someone at one of our lectures gave us a pregnant female moth. By morning she had laid her eggs. We were excited to learn she was a Royal Walnut moth, but a little worried, too: we didn't have host trees to feed Royal Walnut moth caterpillars. Luckily our neighbors didn't mind providing us with leaves. Our caterpillars liked black walnut leaves best.

HOST PLANTS Walnut, hickory, ash, butternut, cherry, lilac, pecan, sumac, and sycamore trees

EGGS

▼ The Royal Walnut's large, yellowish eggs hatch in about ten days. They become clear just before the caterpillars emerge.

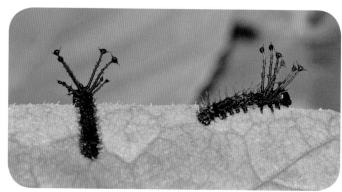

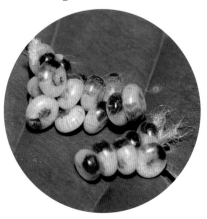

CATERPILLAR

▲ Newborns are all black, with large horns almost as long as their bodies.

▶ As it grows and molts, the caterpillar changes to brown, with striking angled markings.

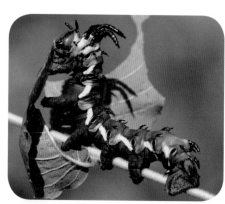

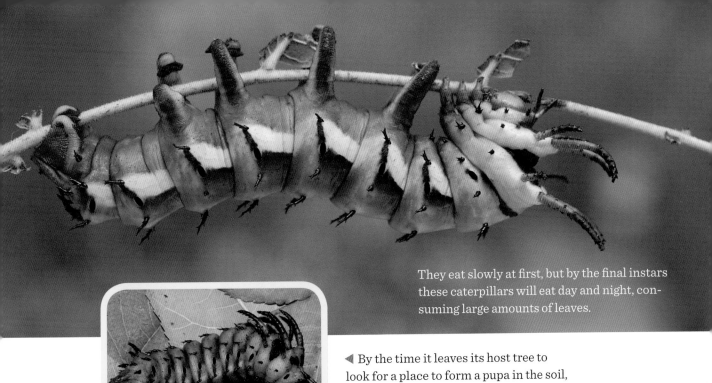

They eat slowly at first, but by the final instars these caterpillars will eat day and night, consuming large amounts of leaves.

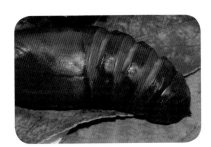

◀ By the time it leaves its host tree to look for a place to form a pupa in the soil, the caterpillar has turned an aqua-green; this is when most people see it.

PUPA

▼ Large and yellow-orange at first, the pupa darkens almost to black as it dries. It may twitch violently if it's disturbed. The pupa overwinters underground until warm spring days arrive.

ADULT

▶ Adult Royal Walnut moths are found mostly in deciduous-forested areas. They produce one generation each year.

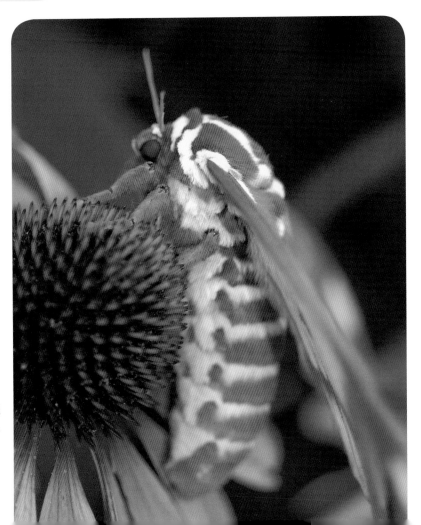

SNOWBERRY CLEARWING HUMMINGBIRD MOTH

Hemaris diffinis

This is one of our favorite flower garden visitors. While at first glance you might think it's a bumblebee, don't worry: a Clearwing moth cannot sting or bite. It might even let you approach it and gently pet its fuzzy body as it eats. A day-flying moth, the Clearwing is a valuable pollinator. Like a hummingbird, it can hover above blossoms while extracting nectar.

One day at a plant nursery, we noticed newly laid eggs and green and brown caterpillars of many sizes on some coral honeysuckle vines. We bought the vines and were thrilled to learn that the inhabitants were all Snowberry Clearwing caterpillars. These moths were very easy to hand-raise, and now that we have their host plants, we enjoy watching their life cycle unfold each summer in our gardens.

HOST PLANTS Honeysuckle, snowberry, dogbane

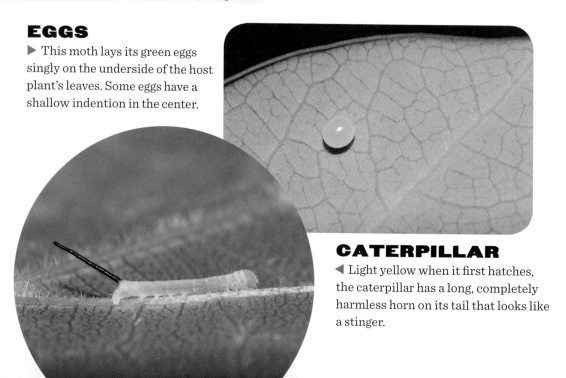

EGGS
▶ This moth lays its green eggs singly on the underside of the host plant's leaves. Some eggs have a shallow indention in the center.

CATERPILLAR
◀ Light yellow when it first hatches, the caterpillar has a long, completely harmless horn on its tail that looks like a stinger.

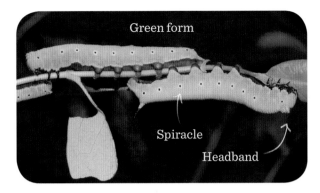

Green form

Spiracle

Headband

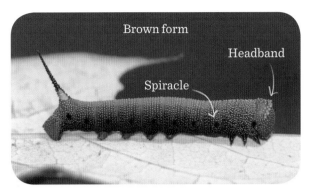

Brown form

Headband

Spiracle

▲ As the caterpillar molts, its color forms can range from bright green to reddish brown. Black breathing pores, called *spiracles*, become pronounced as the caterpillar grows, and it develops what resembles a yellow headband. When it is ready to pupate, the caterpillar leaves its host plant and burrows into loose soil.

PUPA

▶ The caterpillar makes its cocoon by spinning silk around some dirt.

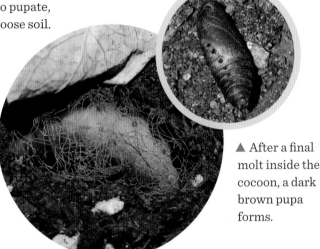

▲ After a final molt inside the cocoon, a dark brown pupa forms.

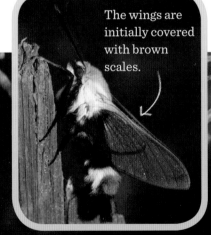

The wings are initially covered with brown scales.

ADULT

The adult moth emerges from the dirt and climbs up a stick or plant to dry and harden its wings.

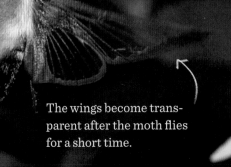

The wings become transparent after the moth flies for a short time.

ISABELLA TIGER MOTH

Pyrrharctia isabella

Banded Woolly Bears, also called woolly worms, are a common sight in autumn, crawling across sidewalks and driveways, trying to find a safe spot to hide before winter weather arrives. They are covered in stiff black hairs with a band of orange hairs around their middle, and their cuddly looking exterior makes them irresistible to children. Although lots of people believe the myth that Woolly Bear coloration predicts the severity of the coming winter, the size of the caterpillar's bands simply changes as it matures.

HOST PLANTS Grass, clover, dandelion, plantain, nettle, lettuce

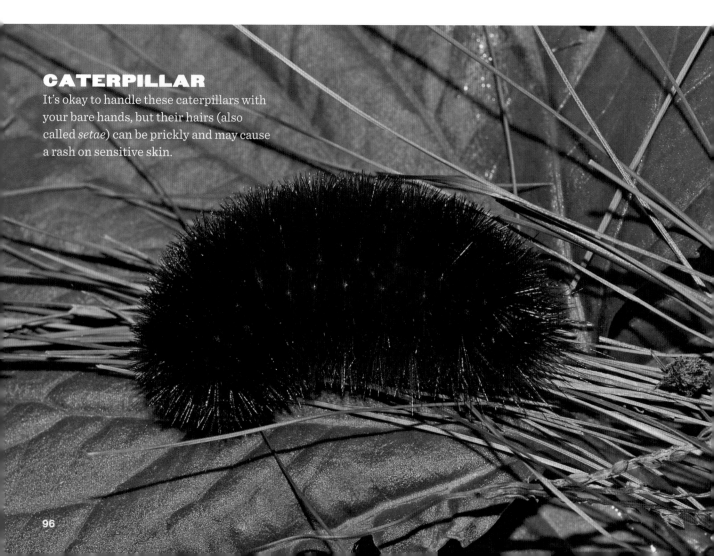

CATERPILLAR

It's okay to handle these caterpillars with your bare hands, but their hairs (also called *setae*) can be prickly and may cause a rash on sensitive skin.

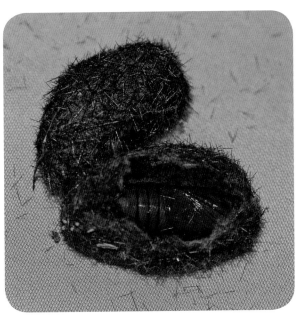

▲ Fast on their feet on warm days, the caterpillars' metabolism slows as the temperature falls, and they enter a state of hibernation. You can find them sleeping under loose rocks, logs, or anything else that provides shelter and protection.

PUPA

▲ As the weather warms up again in the spring, the caterpillars wake. They find grass, clover, or plant leaves to eat and then spin a cocoon using silk and their own body hairs so they can finish their metamorphosis into Isabella Tiger moths.

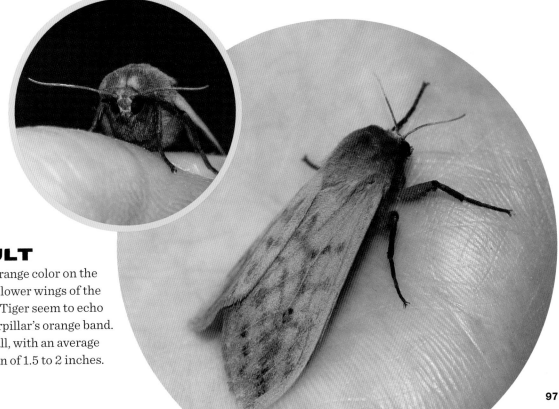

ADULT

▶ The orange color on the legs and lower wings of the Isabella Tiger seem to echo the caterpillar's orange band. It is small, with an average wingspan of 1.5 to 2 inches.

TOBACCO HORNWORM MOTH

OTHER NAMES: CAROLINA SPHINX, SIX-SPOTTED SPHINX, TOBACCO FLY

Manduca sexta

This is one of the most hated of all moths because of the destruction caused by its caterpillars. Though it is officially called a Tobacco Hornworm moth, we found all the eggs on our tomato plants. The Tobacco Hornworm will happily devour either or both plants, much to the disgust of tobacco growers and vegetable farmers.

HOST PLANTS Tobacco, tomato plants, horse nettle, plants in the nightshade family

EGGS
◀ This moth's light green eggs can be found mainly on the lower leaves of host plants. The female lays them at night.

CATERPILLAR
▼ The caterpillars are light yellow when newly hatched, with a long black tail — not a stinger! — referred to as a horn. The horn turns from black to red after a few molts, and vivid white, angled stripes develop.

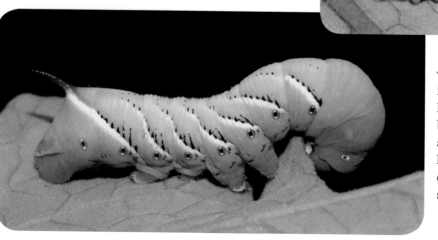

◀ Although when disturbed it may occasionally rise up like a snake ready to strike, both the caterpillar and its alarming-looking horn are harmless to humans. The caterpillar burrows into the soil to pupate underground.

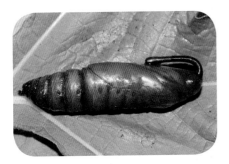

PUPA

▲ The Tobacco Hornworm's pupa is large and brown.

ADULT

▶ The adult moth flies only after dark. It feeds on flowers, and is sometimes mistaken for a hummingbird because of its ability to hover on fast-moving wings. Its average wingspan is between 3.5 and 4.5 inches.

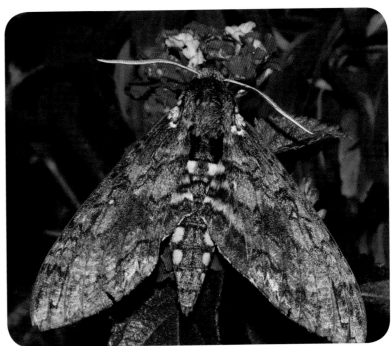

WASP VS. WORM

Tobacco Hornworm caterpillars have insect enemies as well as human ones: they're on the menu for a species of small parasitic wasp. The wasp first lays its eggs on the caterpillar. When the tiny wasp larvae hatch, they burrow into the caterpillar, which at first seems unaffected. It is only when the wasp larvae burrow back out of the caterpillar and form cocoons all over its outer body surface that the damage becomes visible. The caterpillar will not pupate and eventually dies.

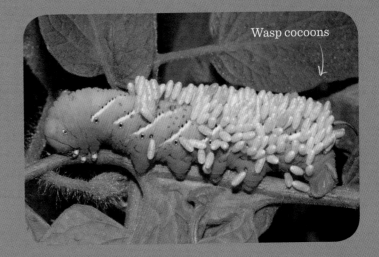

Wasp cocoons

GIANT LEOPARD MOTH
OTHER NAME: EYED TIGER MOTH

Hypercompe scribonia

Another kind of woolly worm you may find in your garden in the fall is covered with solid black, bristlelike hairs and has bright red stripes on its skin. This caterpillar also hibernates through the cold months, then changes into a Giant Leopard moth in the spring.

HOST PLANTS Grass, violet leaves, dandelion, sunflower, plantain; cherry, oak, and willow trees

CATERPILLAR

▶ The caterpillar rolls up when disturbed; that's when you can get a peek at its red coloration. Be aware that its bristles can break off and cause skin irritation.

ADULT

▼ With its 3-inch wingspan, the Giant Leopard moth is appropriately named.

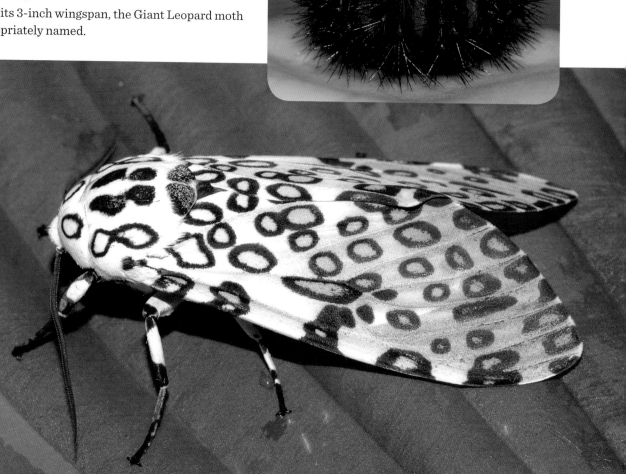

Raising Moth Caterpillars

Woolly worms and some other moth caterpillars are easy to raise and care for. Collect a couple of the caterpillars when you see them in the fall (be careful when handling fuzzy caterpillars; they can cause skin irritation). Place them in a container with holes in the lid, put in a stick for them to climb on, and follow these simple rules:

- **Provide fresh host-plant leaves for them to eat every day.**

- **Be sure to keep them outside in an unheated but protected area like a porch, garage, or shed.**

- **When the weather gets cold and they stop eating, don't give them any more new leaves.**

- **Start feeding them again in the spring, until they form their cocoons.**

- **Once the moths emerge, they will climb up the stick you've provided so their wings can hang down to dry. Release the moths after sunset so they don't get eaten by birds.**

On the following pages are some moth caterpillars that can be raised at home. If you find a caterpillar eating a particular plant, be sure to provide it with that exact plant as food, as some moth caterpillars are very specific about what they will eat.

SOME MOTHS TO RAISE

▶ **EIGHT-SPOTTED FORESTER MOTH**
EATS Grapevine leaves

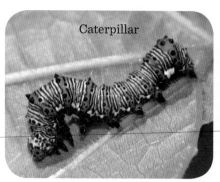
Caterpillar

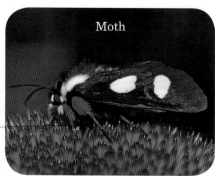
Moth

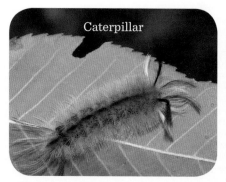
Caterpillar

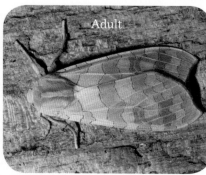
Adult

◀ **BANDED TUSSOCK MOTH (OR PALE TIGER MOTH)**
EATS Tree leaves such as those of elm, hackberry, walnut, and willow.
Caution: This caterpillar's hairs can cause skin irritation

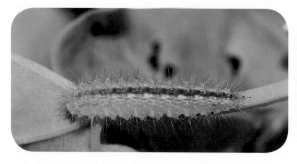

▲ **MORNING GLORY PLUME MOTH**
EATS Morning glory and bindweed plants

▶ **MILKWEED TIGER MOTH (OR MILKWEED TUSSOCK MOTH)**
EATS Milkweed plants

Caterpillar

Moths

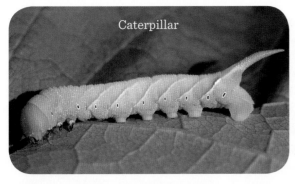
Caterpillar

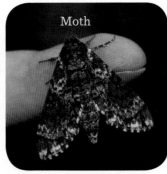
Moth

◀ **PAWPAW SPHINX MOTH**
EATS Pawpaw leaves

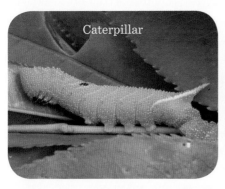
Caterpillar

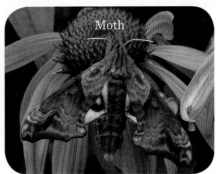
Moth

▲ **SMALL-EYED SPHINX MOTH**
EATS Wild cherry tree leaves

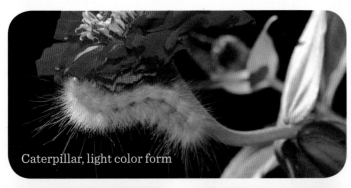
Caterpillar, light color form

◀ **VIRGINIA TIGER MOTH**
EATS Many weeds, including clover and grasses; zinnia flowers

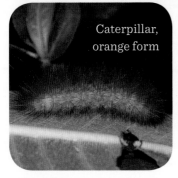
Caterpillar, orange form

Moth and eggs

About Spiders

Love them or hate them, spiders can be found almost everywhere, creeping, crawling, and often evoking terror. During the warm summer months, some spin their webs across our gardens, giving us a sticky morning greeting. Others hide, waiting to jump on unsuspecting prey. But we're not what the spiders are hoping to catch — it's insects they're after.

Unlike insects, spiders — arachnids — do not have antennae. They use the sensitive hairs on their legs to pick up scents, sounds, vibrations, and air currents. They're excellent garden predators, devouring many types of harmful insects.

A word of caution, however: It's a good idea to treat spiders with respect. They are all venomous to some degree, and they'll bite when they feel threatened. Learn the right way to handle spiders, and play it safe to prevent injury.

To simplify identification of some common spiders, we separate them into three very basic categories: *orb-weavers, lie-in-waits,* and *jumpers.*

ORB-WEAVERS

Orb-weavers make flat, spiral webs and let their prey come to them. These spiders can spin different kinds of silk for different tasks: one for building webs, another for wrapping prey, and a third for making egg sacs. They eat their webs if they become damaged, and may create a new one every day if necessary.

Garden spiders, also known as "writing spiders," are our favorite spiders. They make big round webs on taller plants in sunny areas. Their webs are easy to recognize: they're large, with an obvious zigzag design in the center.

▼ We'd seen adult garden spiders in our mother's gardens for many years, but late last summer was the first time we ever found egg sacs hanging in a spider's web.

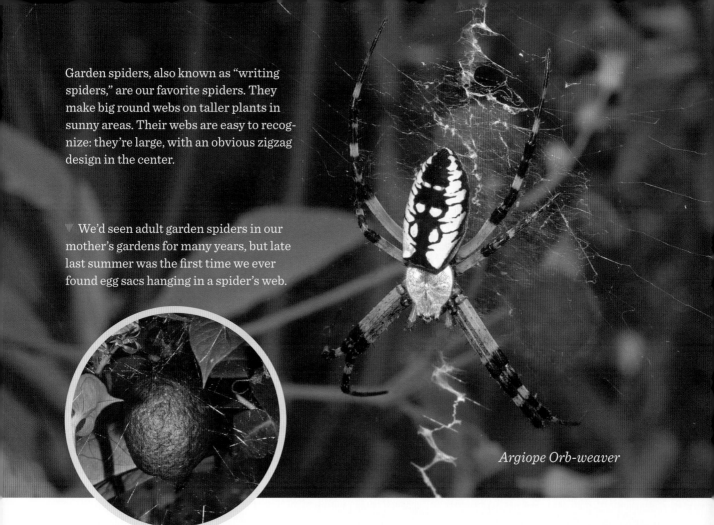

Argiope Orb-weaver

Spiny Orb-weaver

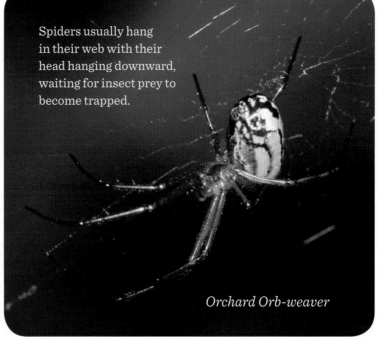

Spiders usually hang in their web with their head hanging downward, waiting for insect prey to become trapped.

Orchard Orb-weaver

LIE-IN-WAITS

Crab spiders (like all those on this page) do not build webs, but rather lie motionless in wait — sometimes for hours — in flowers or other hideouts, ready to ambush their prey. Like their namesake, crab spiders can move sideways and backwards.

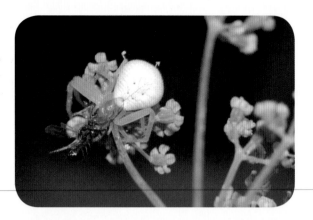

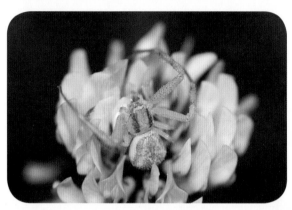

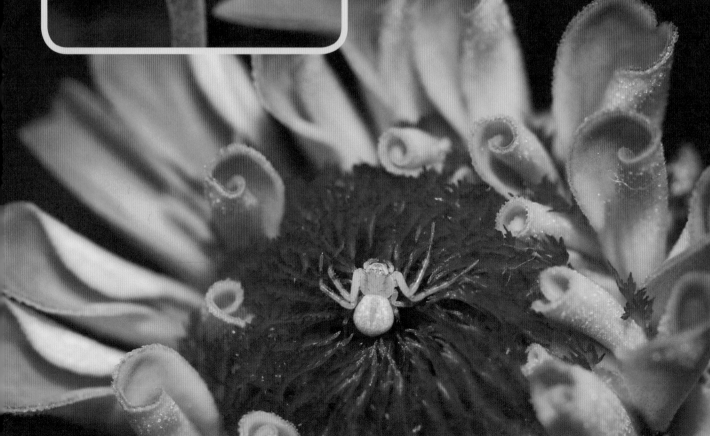

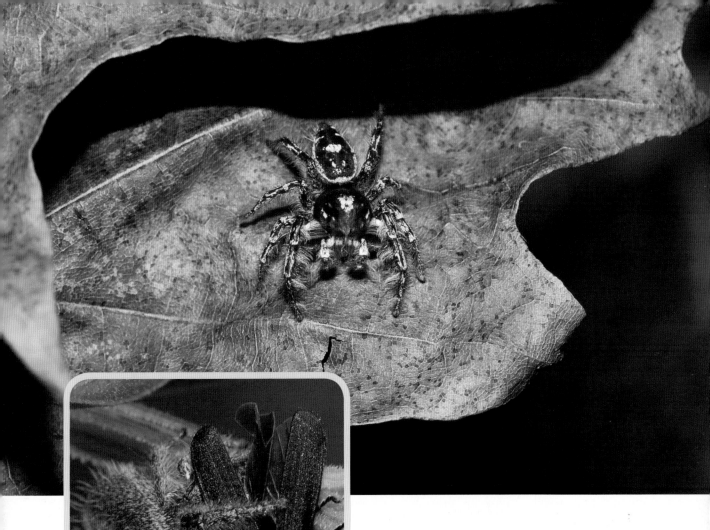

JUMPERS

Jumping spiders are constantly in motion. They have four pairs of eyes with very large front ones, giving them excellent vision that makes them keen hunters of insect prey. They are incredibly fast on their "feet," and they use this speed to catch their meals. Jumping spiders do not spin webs; instead, they anchor a silk line to whatever they're standing on as a safety tether in case they fall when jumping.

BLACK WIDOW

Latrodectus mactans

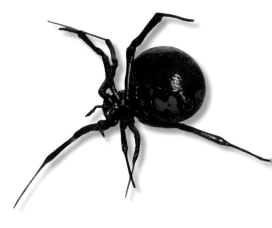

A serious warning is needed here: Do not attempt to rear these spiders in your home! We raised them only in order to photograph their life cycle. Black Widows can move quickly and are the most venomous spider in North America. Their venom is a neurotoxin that affects nerve impulses to the muscles. Those bitten may experience painful muscle cramps and spasms in the chest and abdomen, increased blood pressure, fever, weakness, and nausea. It's always a good idea to wear gloves and long sleeves if you plan to handle firewood, rocks, or other items that have been sitting outside for a while and could offer spiders a likely hiding place.

The Black Widow can be found in most parts of North America and generally builds its cobweb in a sheltered area — between logs in a woodpile, inside a rodent burrow, under loose rocks, or inside a barn or outbuilding. Females may live for two or three years, making several egg sacs each summer. Black Widows help keep insect populations under control. They eat cockroaches, beetles, crickets, and just about anything else that wanders into their webs.

EGGS

▼ A lie-in-wait spider, the Black Widow female lays her eggs in groups of about 100; wraps them in a protective, pear-shaped sac of strong silk; and guards them aggressively.

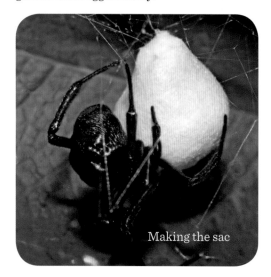

Making the sac

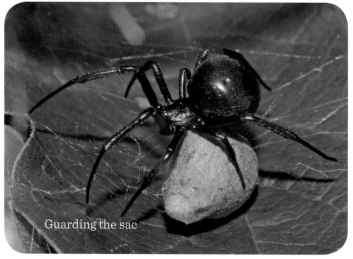

Guarding the sac

SPIDERLINGS

▼ The eggs hatch within several weeks. Tiny and translucent when born, the spiderlings remain inside the sac until after their first molt.

▼ After leaving the sac, the baby spiders spin a communal cobweb and stay together for several days, catching and eating small insects they trap. The spiders we raised ate their siblings as well, perhaps because they were reared in an enclosed container. In their natural habitat, they eventually disperse to make their own webs.

▼ Young spiders molt up to eight times as they outgrow their exoskeletons.

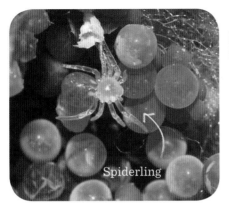

Spiderling

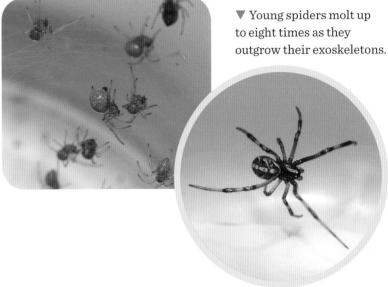

ADULTS

▼ Males and females develop different coloration as they mature. The female Black Widow has a distinctive bright red hourglass on her belly.

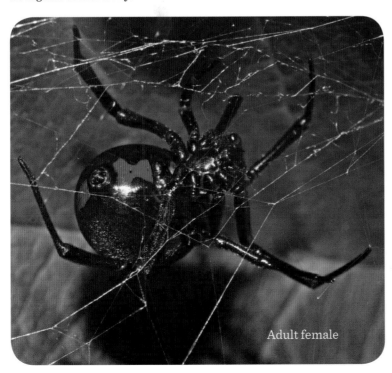

Adult female

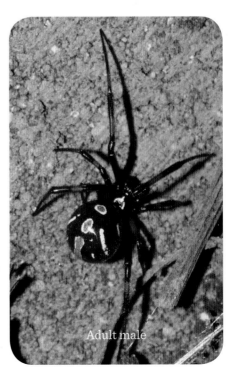

Adult male

EASY COMPARISON GUIDE: EGGS

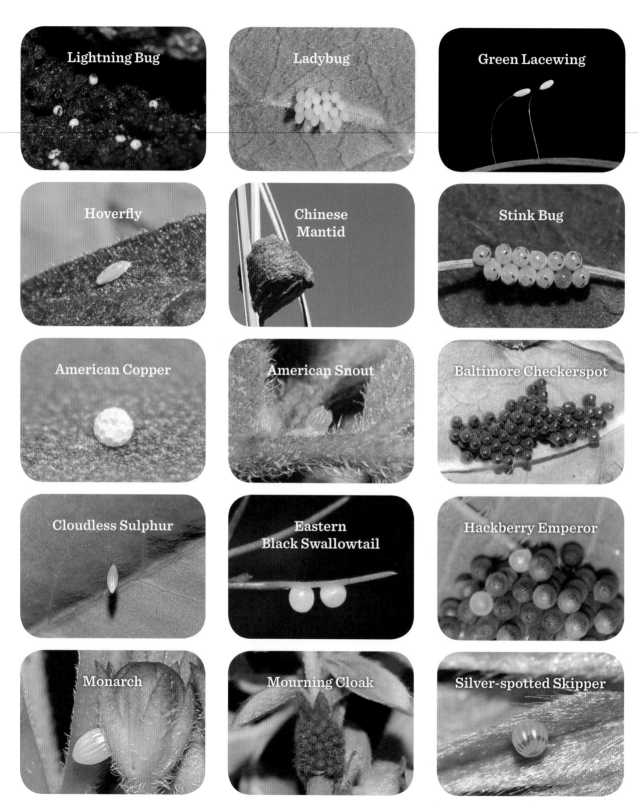

Lightning Bug	Ladybug	Green Lacewing
Hoverfly	Chinese Mantid	Stink Bug
American Copper	American Snout	Baltimore Checkerspot
Cloudless Sulphur	Eastern Black Swallowtail	Hackberry Emperor
Monarch	Mourning Cloak	Silver-spotted Skipper

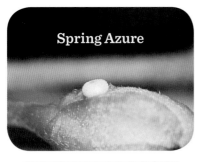
Spring Azure

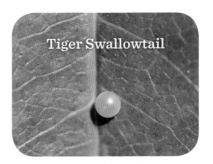
Tiger Swallowtail

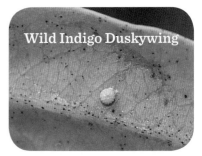
Wild Indigo Duskywing

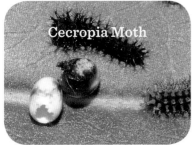
Cecropia Moth

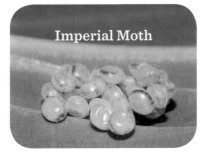
Imperial Moth

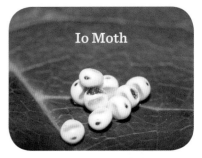
Io Moth

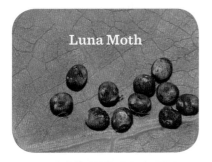
Luna Moth

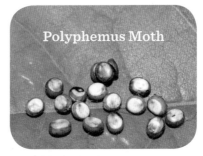
Polyphemus Moth

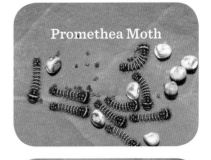
Promethea Moth

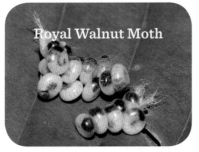
Royal Walnut Moth

Snowberry Clearwing
Hummingbird Moth

Tobacco Hornworm Moth

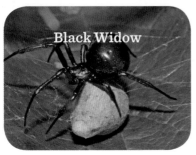
Black Widow

EASY COMPARISON GUIDE: LARVAE

Lightning Bug

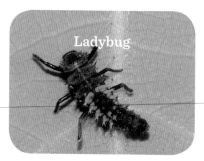
Ladybug

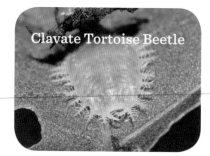
Clavate Tortoise Beetle

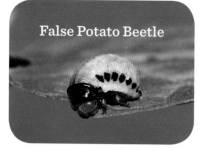
False Potato Beetle

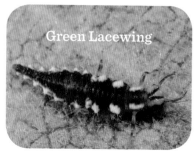
Green Lacewing

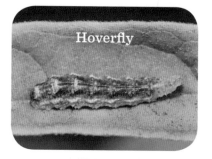
Hoverfly

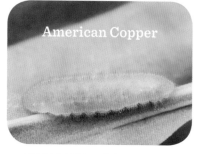
American Copper

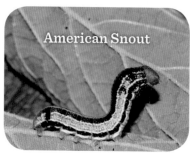
American Snout

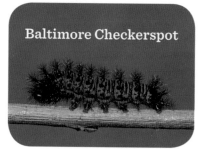
Baltimore Checkerspot

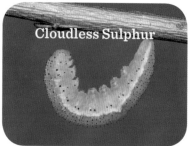
Cloudless Sulphur

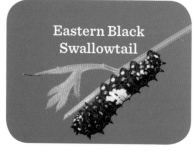
Eastern Black Swallowtail

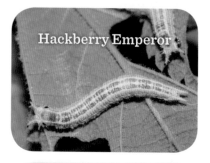
Hackberry Emperor

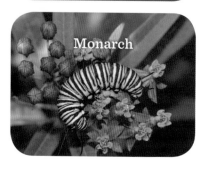
Monarch

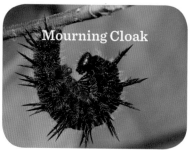
Mourning Cloak

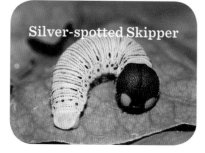
Silver-spotted Skipper

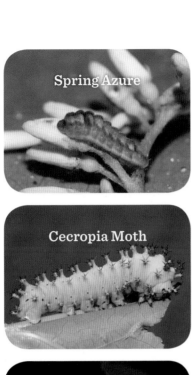

Spring Azure

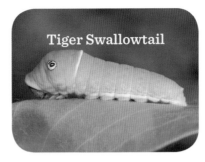

Tiger Swallowtail

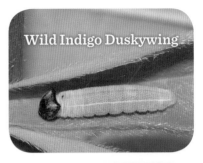

Wild Indigo Duskywing

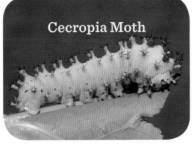

Cecropia Moth

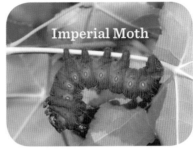

Imperial Moth

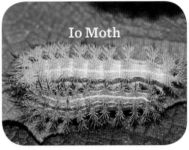

Io Moth

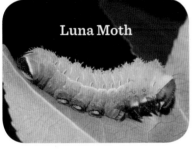

Luna Moth

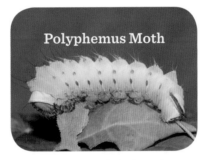

Polyphemus Moth

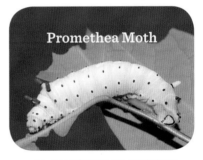

Promethea Moth

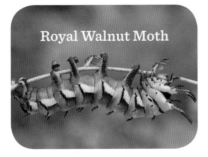

Royal Walnut Moth

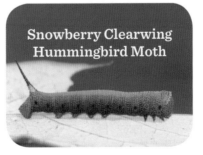

Snowberry Clearwing
Hummingbird Moth

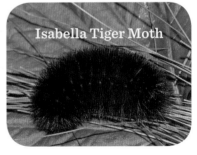

Isabella Tiger Moth

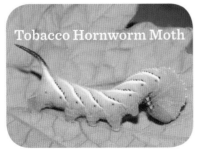

Tobacco Hornworm Moth

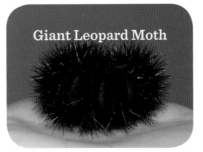

Giant Leopard Moth

EASY COMPARISON GUIDE: PUPAE

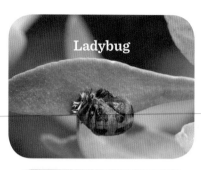
Lightning Bug

Ladybug

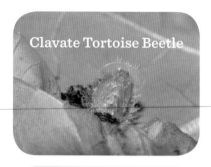
Clavate Tortoise Beetle

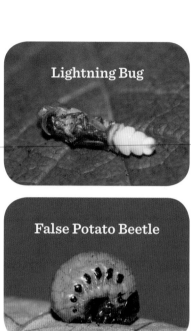
False Potato Beetle

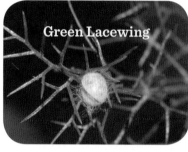
Green Lacewing

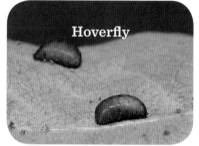
Hoverfly

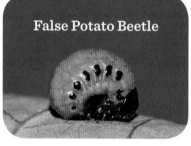
American Copper

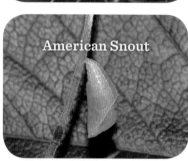
American Snout

Baltimore Checkerspot

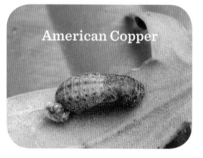
Cloudless Sulphur

Eastern Black Swallowtail

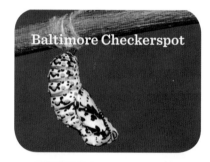
Hackberry Emperor

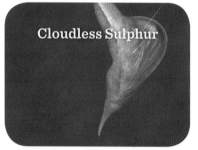
Monarch

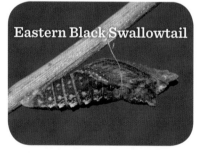
Mourning Cloak

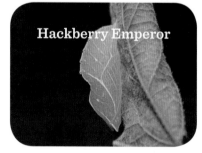
Silver-spotted Skipper

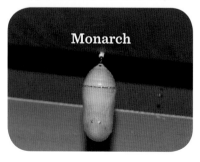

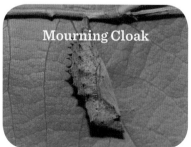

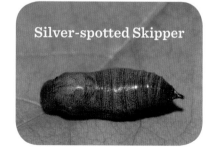

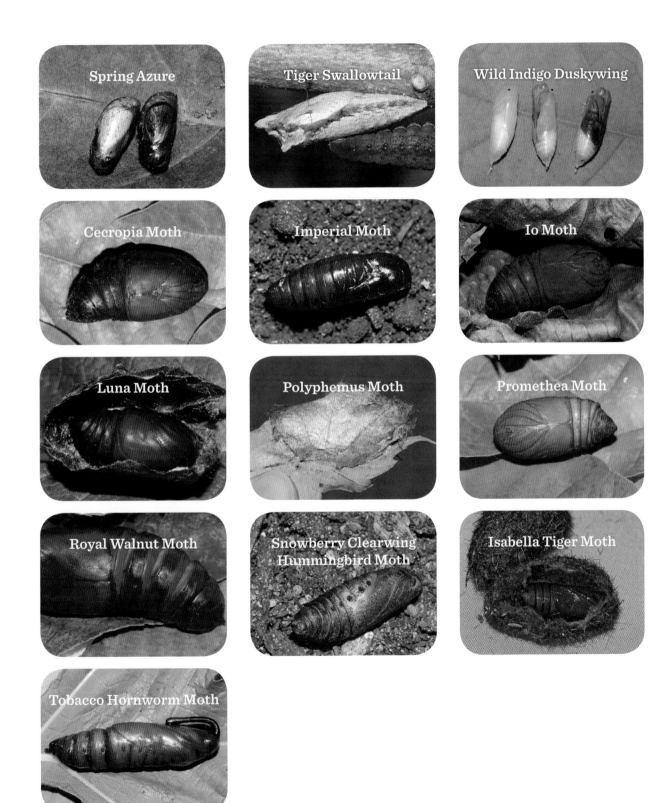

Spring Azure

Tiger Swallowtail

Wild Indigo Duskywing

Cecropia Moth

Imperial Moth

Io Moth

Luna Moth

Polyphemus Moth

Promethea Moth

Royal Walnut Moth

Snowberry Clearwing
Hummingbird Moth

Isabella Tiger Moth

Tobacco Hornworm Moth

EASY COMPARISON GUIDE: ADULTS

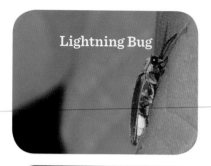
Lightning Bug

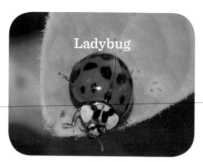
Ladybug

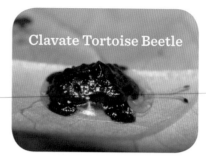
Clavate Tortoise Beetle

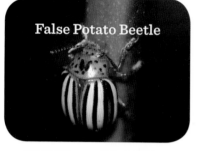
False Potato Beetle

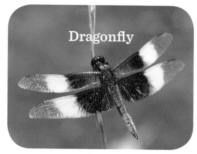
Dragonfly

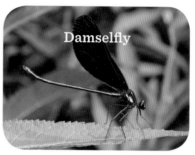
Damselfly

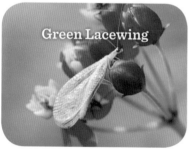
Green Lacewing

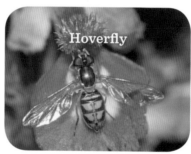
Hoverfly

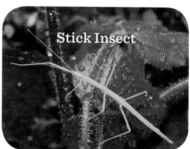
Stick Insect

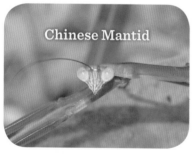
Chinese Mantid

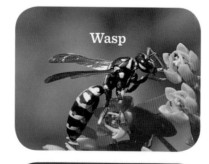
Wasp

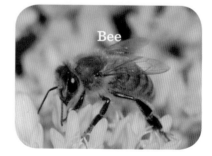
Bee

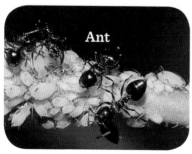
Ant

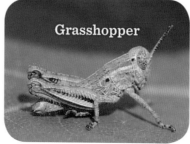
Grasshopper

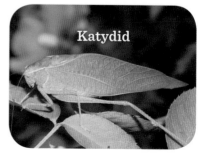
Katydid

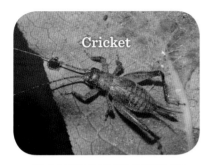
Cricket

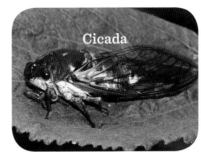
Cicada

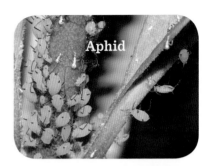
Aphid

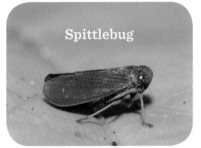
Spittlebug

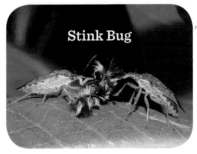
Stink Bug

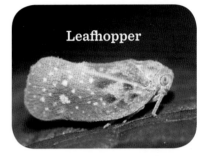
Leafhopper

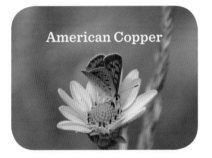
American Copper

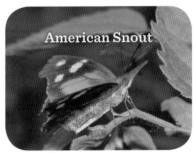
American Snout

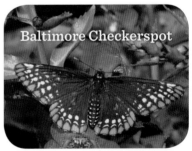
Baltimore Checkerspot

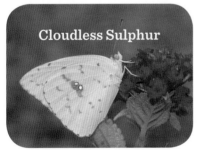
Cloudless Sulphur

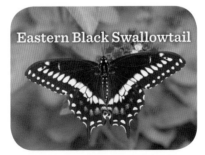
Eastern Black Swallowtail

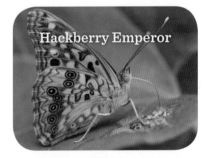
Hackberry Emperor

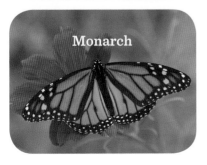
Monarch

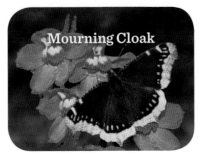
Mourning Cloak

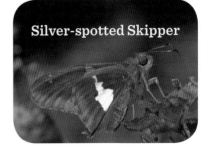
Silver-spotted Skipper

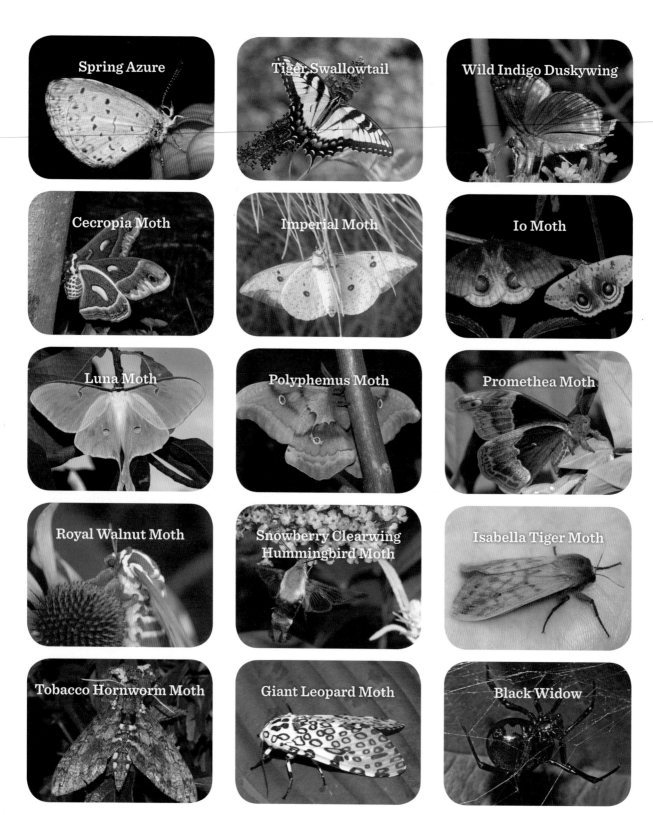

Spring Azure

Tiger Swallowtail

Wild Indigo Duskywing

Cecropia Moth

Imperial Moth

Io Moth

Luna Moth

Polyphemus Moth

Promethea Moth

Royal Walnut Moth

Snowberry Clearwing Hummingbird Moth

Isabella Tiger Moth

Tobacco Hornworm Moth

Giant Leopard Moth

Black Widow

Our Top Host and Nectar Plants

We grow all of these plants in our gardens to attract an incredible diversity of insect life that feeds on the plants themselves, seeks out the nectar and pollen as their food source, or preys on other insects found on the plants.

◄ BRONZE FENNEL*

Foeniculum vulgare

The blooms attract a wide variety of small bees, hoverflies, wasps, beetles, and tiny butterflies. Bronze fennel is also a host plant for Black Swallowtail butterfly caterpillars and attracts praying mantids hunting small prey.

▼ WHITE CLOVER*

Trifolium repens

The blossoms attract plenty of honeybees, and the leaves are host for some Sulphur butterflies. White clover is also a hardy ground cover and nitrogen-fixer (good for lawns).

▲ ZINNIAS

Zinnia elegans

The flowers attract all sizes of bees, moths, and butterflies, and are a favorite hiding spot and hunting ground for crab spiders and praying mantids.

◄ TOMATO PLANTS
Solanum lycopersicum

Because these attract some aphids, the lacewings, ladybugs, and hoverflies tend to lay their eggs on tomato plants so that their larvae will have a ready food source. Tomatoes are also hosts plants for Sphinx moth caterpillars.

▲ BLOOD FLOWER MILKWEED*
Asclepias curassavica

A host for Monarch butterfly caterpillars and also milkweed beetles, the blood flower milkweed also attracts many kinds of butterflies, moths, bees, and a few wasps with its blossoms. Lacewings, ladybugs, and hoverflies lay their eggs on the plant, and their larvae eat the aphids nearby.

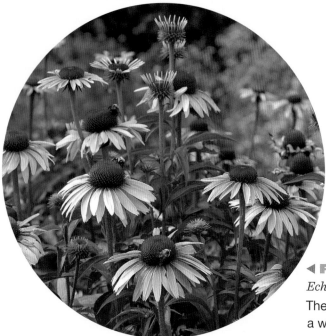

◄ PURPLE CONEFLOWER
Echinacea purpurea

The blooms of the purple coneflower attract a wide variety of bees, moths, and butterflies.

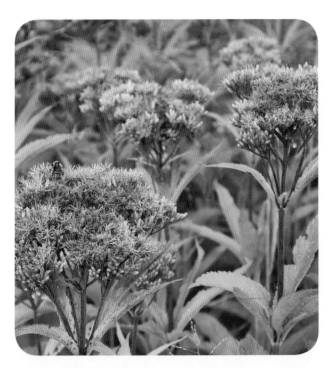

◄ JOE-PYE WEED
Eupatoriadelphus fistulosus

The blooms of this "weed" attract an array of bees, moths, wasps, beetles, and butterflies.

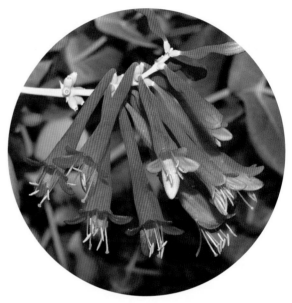

▲ CORAL HONEYSUCKLE
Lonicera sempervirens

A host plant for Snowberry Clearwing moth caterpillars, the coral honey-suckle's blooms also attract larger-sized butterflies like the Swallowtails.

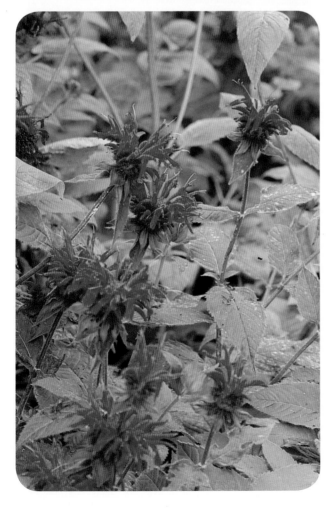

◄ SCARLET BEE BALM
Monarda didyma

The flowers of this bee balm attract bees and butterflies.

▶ NEW ENGLAND ASTER
Symphyotrichum novae-angliae

A nice range of bees, butterflies, beetles, and moths visit the blooms of the New England aster. It is also a host plant for Pearl Crescent butterfly caterpillars.

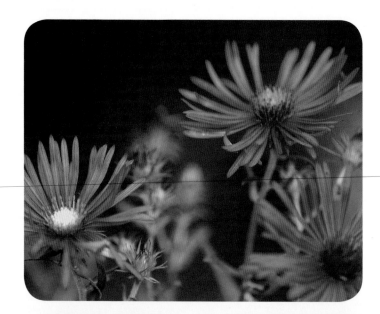

▶ STONECROP
Sedum telephium

The blooms attract fall migrating butterflies like Buckeyes and Painted Ladies, as well as a variety of bees, beetles, and wasps.

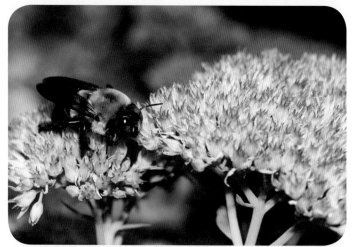

▶ VERBENA*
Verbena bonariensis

Butterflies and moths are enticed by the verbena's blooms.

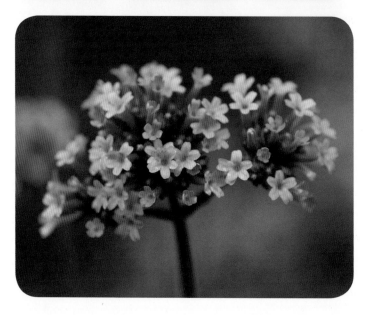

SPECIAL THANKS

We want to extend a special thanks to all of our family, friends, and readers who have supported us over the years. We are grateful that you have encouraged us to pursue our dreams and strive to excel in our nature photography and writing endeavors. We hope our books shed a beautiful light on the amazing life cycles of the creatures living in your own backyards. From the curious to the serious, we want to teach every reader something new. Please visit our website, *www.butterflynature.com*.

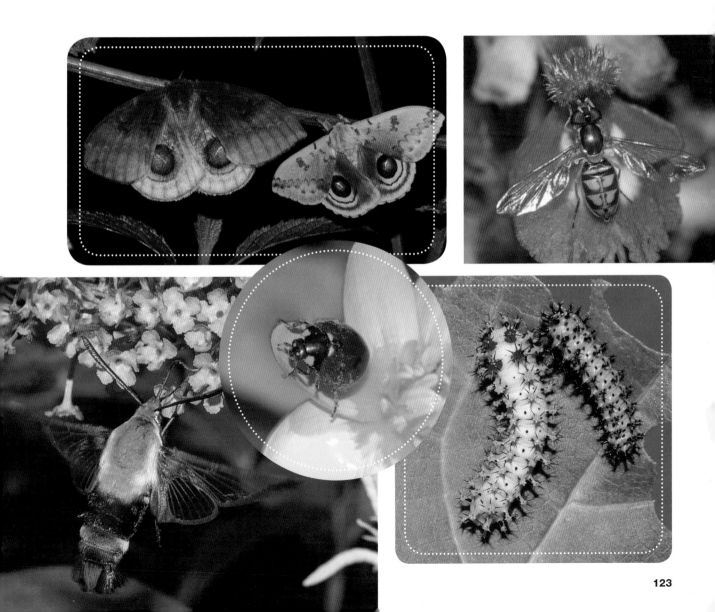

GLOSSARY

ABDOMEN The rear part of an insect's body containing the digestive and reproductive organs

AESTIVATION *See* **estivate**

ANNUAL Any plant that lives for just one season and doesn't come back next year from its roots

ANTENNAE A pair of sensory organs on an insect's head used to touch and smell its environment

ARACHNID Eight-legged invertebrate without antennae or wings

BASKING Spreading wings open and sitting still in the sunlight to absorb heat

BUG Common name for the insect order called Hemiptera, meaning "half wings"; mouthparts enable them to pierce plant fibers and suck their juices; also called *true bugs*

CHRYSALIS Pupa of a butterfly enclosed in a firm case or cocoon

COCOON A case, spun from silk threads, that envelops the chrysalises of moths and a few butterflies, especially skippers

COMPLETE METAMORPHOSIS The process of going through egg, larval, pupal, and adult stages, each form of which bears little resemblance to the others

COMPOST Nutrients and organic particles that enrich the soil for plants

COMPOUND EYES Large insect eyes composed of hundreds of tiny lenses

DIAPAUSE The winter resting phase of some chrysalises and a few caterpillars; also called *hibernation*

ECLOSION The emergence from a chrysalis or cocoon as an adult butterfly or moth

ELYTRA (SINGULAR: ELYTRON) Hard front wings that cover and protect a beetle's delicate, hidden hind wings

ESTIVATE Become dormant during a hot, dry season

EXOSKELETON The shell that forms the outside of an insect's body; insects don't have bones

GIRDLE A loop of silk that supports a chrysalis in an upright position; Swallowtail caterpillars spin these loops

GRUB *See* **larva**

HEMOLYMPH The blood of an insect

HERMAPHRODYTE Having both male and female reproductive organs

HOST PLANT A specific plant on which insects lay their eggs; after they hatch, the larvae feed on the host plant

INCOMPLETE METAMORPHOSIS Transformation stages during which juveniles look very much like the mature adult

INSECT *Arthropod* with a three-part body (*head*, *thorax*, and *abdomen*), a hard *outer skeleton*, three pairs of *jointed legs*, *compound eyes*, and two *antennae*

INSTAR Growth period between each molt of the old skin

INVERTEBRATE A creature that does not have a backbone; this category includes all insects

LARVA The caterpillar phase of a butterfly or moth; in other insects, a juvenile phase that is distinctly different from the adult form

LIFE CYCLE An organism's stages of development, in insects often comprising egg, caterpillar, pupa, and adult

LUCIFERASE Enzyme that reacts with oxygen to produce a cold, chemically induced light, as that of lightning bugs

LOCUSTS Short-horned grasshoppers in large, destructive swarms

MECONIUM Fluid left over from metamorphosis, excreted by a newly emerged adult butterfly or moth

METAMORPHOSIS The transformation of an insect or spider from one life-cycle stage to another

MICROBES Microscopic organisms, such as fungi and bacteria, that are critical for nutrient recycling

MOLTING The shedding of an old skin to reveal a looser, new skin underneath to grow into

MYCELIUM Underground network of filaments that support mushrooms

NAIAD *See* **nymph**

NECTAR The sugary liquid produced by flowers that attracts bees, butterflies, hummingbirds, and moths

NYMPH Young form of some insects or spiders that looks very much like the adult form

OOTHECA Foaming liquid, secreted by female mantids, that hardens to form a protective case around the eggs

OSMETERIUM A gland hidden behind a Swallowtail caterpillar's head that releases a foul odor for defense

OVIPOSITOR A long, pointed organ used to deposit eggs; sometimes mistaken for a stinger

PALPS A pair of furry appendages on the face of a butterfly or moth that protect the proboscis when it is curled up

PARTHENOGENESIS Reproductive process in some insects in which females don't need males to reproduce; instead, they lay eggs containing clones of themselves

PEDICEL Well-defined "waist" structure between the thorax and abdomen of ants, wasps, and bees

PERENNIAL A nonwoody plant living more than two years

PHEROMONES Chemical substances secreted by butterflies and other creatures to attract mates

PISTIL Receptive female part of a flower

POLLINATION Process by which pollen is transferred from one plant to another, enabling reproduction

PROBOSCIS The tongue of butterflies and moths, and some other insects, used to sip nectar; coils up when not in use

PROLEGS Fleshy, sticky legs of a caterpillar, used for clinging to surfaces

PUPA Life-cycle stage experienced by insects that go through complete metamorphosis, after larval stage and before adult; known as *chrysalis* in butterflies, *tumbler* in mosquitoes

RADULA Tonguelike mouthpart of a snail or slug, covered with microscopic teeth with which it scrapes food

REFLEX BLEEDING Defense mechanism used by ladybugs in which they leak yellow blood from leg joints; the liquid smells bad and contains an alkaloid toxin that predators dislike

ROSTRUM The Stink Bug's piercing, tubelike mouthpart

SCALES Tiny, overlapping structures that cover the surface of butterfly or moth wings and absorb heat

SCOLI Colorful knobs that cover the bodies of some caterpillars

SETAE Bristles or hairlike structures, such as those on caterpillars

SIMPLE METAMORPHOSIS *See* **incomplete metamorphosis**

SPINNERET The gland located below the mouth of a caterpillar that spins silk threads

SPIRACLES Pores on the sides of an insect's body used to breathe in air; insects have no lungs

STRIDULATING ORGANS Organs that produce sound by rubbing against each other; best known in crickets and grasshoppers

THORAX Front part of an insect's body containing the muscles connected to the wings and legs

TOPSOIL The layer of earth that contains the nutrients and organic materials needed to produce vigorous, healthy plants

TUBERCLES Lumpy projections covering the bodies of some caterpillars. The Cecropia moth caterpillar also has them.

VERTEBRATE An animal that has a backbone

INDEX

Page numbers in *italics* indicate photos or illustrations.

Discover More about Nature with These Titles from Storey!

From the Same Author:

The Life Cycles of Butterflies
A visual guide, rich in photographs, showing 23 common backyard
butterflies from egg to maturity. Winner of the 2007 Teachers' Choice
Children's Book Award!
160 pages. Paper. ISBN 978-1-58017-617-0.

The Family Butterfly Book by Rick Mikula
Projects, activities, and profiles to celebrate 40 favorite
North American species.
176 pages. Paper. ISBN 978-1-58017-292-9.

Into the Nest by Laura Erickson & Marie Read
Get an intimate look into the family lives of your favorite birds – with beautiful,
close-up photography of over 50 birds and their fledglings, nest building,
brooding, courtship, and much more.
208 pages. Paper. ISBN 978-1-61212-229-8.

Keeping a Nature Journal by Clare Walker Leslie & Charles E. Roth.
Simple methods for capturing the living beauty of each season.
224 pages. Paper with flaps. ISBN 978-1-58017-493-0.

The Nature Anatomy by Julia Rothman
This whimsical visual guide is packed with artful illustrations and rich
insights into our natural world, ranging from geology and astronomy
to zoology, weather, botany, and more!
224 pages. Paper with flaps. ISBN 978-1-61212-231-1.

The Nature Connection by Clare Walker Leslie
An interactive workbook packed with creative, year-round nature activities.
304 pages. Paper. ISBN 978-1-60342-531-5.

These and other books from Storey Publishing are available
wherever quality books are sold or by calling 1-800-441-5700.
Visit us at *www.storey.com* or sign up for our newsletter
at *www.storey.com/signup*.